LiViNG WhilE BlACK

LiViNG WhilE BlACK

Portraits of Everyday Resistance

Ajuan Mance

Foreword by Alicia Garza

CHRONICLE BOOKS

SAN FRANCISCO

For Evelyn and Emilia, whose fearlessness, brilliance, and love give me hope for a better, more just future.

The illustrations "Selling Water While Black" and "Being a Kid While Black" originally appeared in the Spring 2021 issue of academic journal *Literature and Medicine*, volume 39, number 1.

Library of Congress Cataloging-in-Publication Data available.

ISBN 978-1-7972-1686-7

Manufactured in China.

Design by Howsem Huang.

10 9 8 7 6 5 4 3 2 1

Chronicle books and gifts are available at special quantity discounts to corporations, professional associations, literacy programs, and other organizations. For details and discount information, please contact our premiums department at corporatesales@chroniclebooks.com or at 1-800-759-0190.

Chronicle Books LLC
680 Second Street
San Francisco, California 94107

www.chroniclebooks.com

CONTENTS

FOREWORD

By Alicia Garza

I was first introduced to the work of Ajuan Mance sometime in 2013 or 2014. The reason I can't pinpoint the exact date is because it was at that time that #BlackLivesMatter had gone viral, and protests had spread across the country.

Ajuan was a part of an exhibit at a local gallery where their work, *1001 Black Men*, was displayed. They described the project as one "that gives special attention to those identities within Blackness—elders, geeks and nerds, and others—on whose silence and invisibility oppression depends." #BlackLivesMatter was created in 2013, but Ajuan had been drawing these portraits since 2010. A decade later, in 2020, she began her *Living While Black* series, a project that shows Black people of all genders and ages going about the business of life in the fullness of their humanity.

I would say it was impossible to have known that Blackness would take center stage just a few years later, but the seeds were already being planted. Five years prior to the start of the *1001 Black Men* project, the nation watched in horror as Black people in New Orleans were stranded on roofs and bridges in the aftermath of Hurricane Katrina, and the myth of America being post-racial was shattered for many. Three years later, the country elected its first-ever Black president, Barack Obama. Five years after that, a movement emerged.

State-sanctioned violence against Black communities has always been portrayed in terms of gender, with Black men often taking center stage as those who are most impacted by the violence, and, inside Black communities ourselves, as those who need to be saved. It is true that Black men are disproportionately targeted by state violence, and it is also true that Black women, Black people with disabilities, and Black people who are queer, among others, also experience disproportionate levels of state violence.

But there are nuances even inside of these categories, because we did not design these categories for ourselves. Depictions of Black men as young and menacing are used to justify their criminalization. But in Ajuan's work, Black men—Black people of all genders, in fact—are seen differently—as young and as elders, as those some would categorize as nerds or geeks, as disabled, and more—but all of them are shown as human.

Living While Black is an important project, one of seeing ourselves through our own eyes, on our own terms, which helps to set us free. Black people have always known that we are not a monolith—we are rural, urban, wealthy, poor. We are queer and non-binary and trans, elderly and youthful, disabled and migrant. And, in our differences, we share an experience in common of living while Black, all of the ways in which white supremacy shapes our lives and determines our chances. Ajuan's work encourages us to delve beneath the surface and look beyond the superficial categories that we have been assigned. In doing so, we all become a little more three-dimensional—and in seeing the complexity of humanity in these portraits, perhaps we train ourselves to see, celebrate, and have empathy for the humanity in each of us.

INTRODUCTION

On a flyer dated April 24, 1851, unnamed parties caution the "colored people of Boston" to "avoid conversing with the Watchmen and Police Officers" and to "Shun them in every possible manner, as so many HOUNDS on the track of the most unfortunate of your race." Police and other law enforcement agents had been recently granted the authority to enforce the Fugitive Slave Act of 1850, and events in Boston and elsewhere in the United States made clear that no Black person was safe if white men felt empowered to stop, question, and apprehend anyone they suspected of being a fugitive.

In the summer of 2020, as Americans crowded the streets to protest the deaths of George Floyd, Breonna Taylor, and other Black people who lost their lives at the hands of police, I could not help but think back to the "colored people" of 1850s Boston. What would they think not only of the deaths of unarmed Black people at the hands of police, but of the persistent harassment of Black people by non-Blacks whose discomfort with their presence in community settings like libraries, swimming pools, and shopping malls too often ended in demeaning confrontations and 911 calls? How would they respond to this continuing crisis? As a Black artist living through this moment of reckoning, how would I?

As I watched multiethnic, intergenerational, and gender-diverse crowds take to the streets in support of Black lives, I felt moved to act. Because of the severity of the COVID-19

andemic and the medical vulnerabilities of many of those loved, I was unable to join the rallies and marches, and so turned to my sketchbook. At the heart of these protests was a sense of collective rage at the wide gulf between the way law enforcement and others respond to encounters with Black people and the way they respond to encounters with people who are white. The murders of unarmed African Americans and other people of African descent exist at the far end of a continuum that runs from the harassment and reporting of Black people engaged in the activities of everyday life, mostly by white civilians, to the extrajudicial killings of unarmed Black people by white vigilantes and law enforcement officers of all races. I created this series of drawings to highlight the injustice inherent in this selective criminalization of everyday activities.

In this context, routine events like an afternoon jog, a trip to the store, or a trip to the voting booth become acts of resistance. Black people persist in seeing the humanity in themselves and one another and in living freely and joyfully, despite those who regard our presence on their campuses, in their neighborhoods, and on their streets with suspicion and contempt. I use vivid colors and bold patterns and outlines to reflect this spirit of defiance and resolve. As such, the drawings in this book call attention to the divide between the way I see Black people and the distorted perceptions of those who respond to Black people with hypervigilance, outrage, and fear. Although the illustrations in this book capture only a portion of those actions for which Black people have been harassed, reported to police, arrested, and killed, they bear witness to Black people's deep and abiding faith that, ultimately, justice will prevail.

ARTWORK

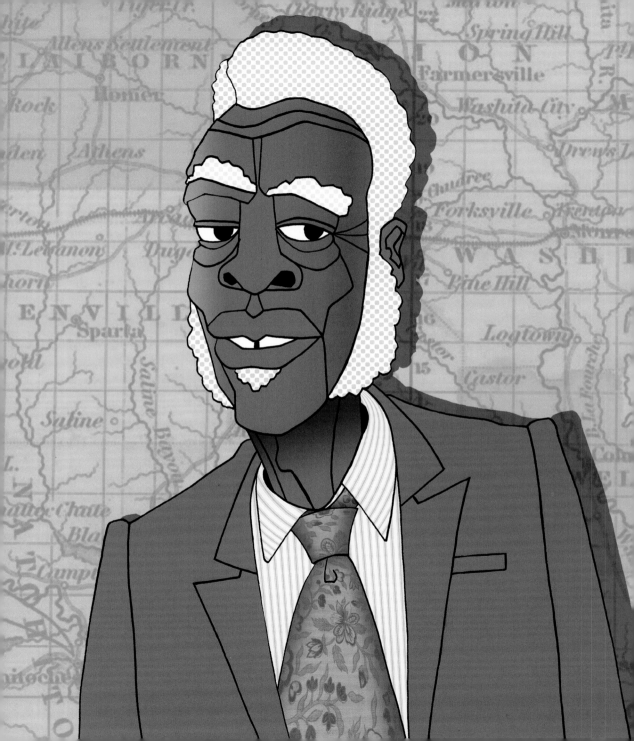

Aging While Black

\ āj-iŋ wī(-ə)l blak \

1) A reference to any act of police violence against medically vulnerable, chronically ill, or disabled Black people over the age of sixty.

2) A phrase applied to encounters in which police officers display an open disregard for the dignity, health, or safety of Black elders.

abbrev. None in use

Attitude While Black

\ a-də-t(j)ud wī(-ə)l blak \

1) A term that describes the arrest or detainment of a Black individual or group for failing to demonstrate submission to or reverence for a law enforcement officer.

2) A cynical reference to the criminalization of Black dignity, audacity, skepticism, or resistance.

abbrev. None in use

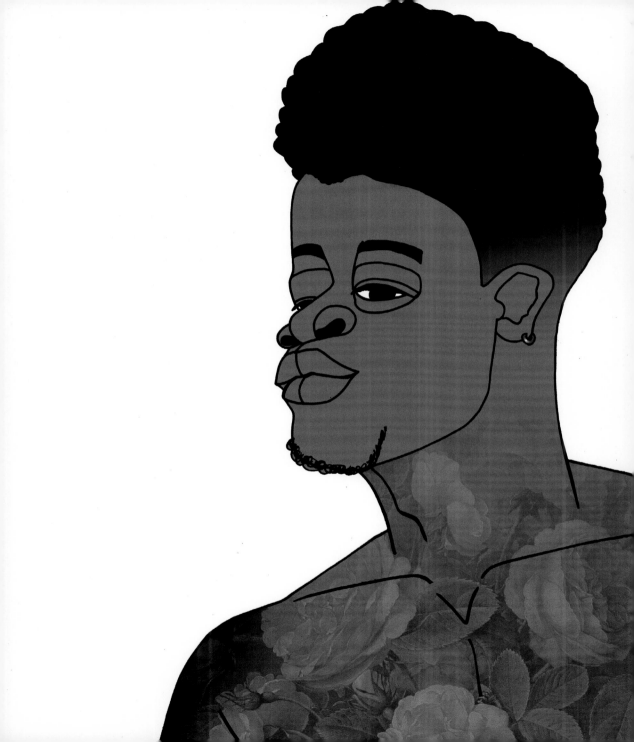

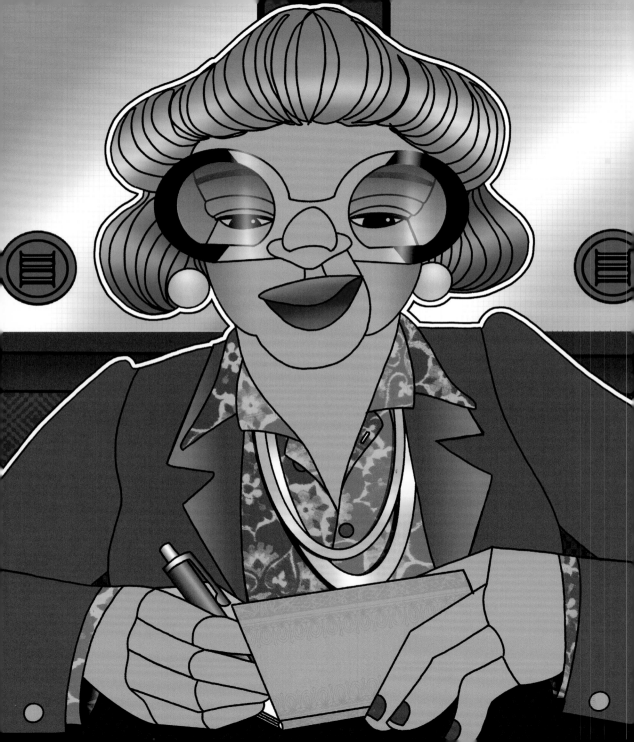

Banking While Black

\ bæŋk-iŋ wī(-ə)l blak \

1) A reference to Black banking customers' experience of refusal of service, denial of access to funds, or excessive requests for identification.

2) A term applied to Black banking customers' subjection to false accusations of fraud by bank tellers, managers, or other employees.

3) A reference to the arrest and detainment of Black banking customers for attempting to complete lawful financial transactions.

abbrev. BWB

Barbecuing While Black

\ bär-bə-kju-iŋ wī(-ə)l blak \

1) A reference to the May 2018 encounter between two Black men having a weekend barbecue, the white woman who reported their barbecue to the police, and the officers who responded to her 911 call, at Lake Merritt in Oakland, California.

2) The annual barbecue festival held by Black Oakland residents to protest efforts to criminalize their use of the city's public spaces.

abbrev. BBQWB; BBQ'nWB; BWB

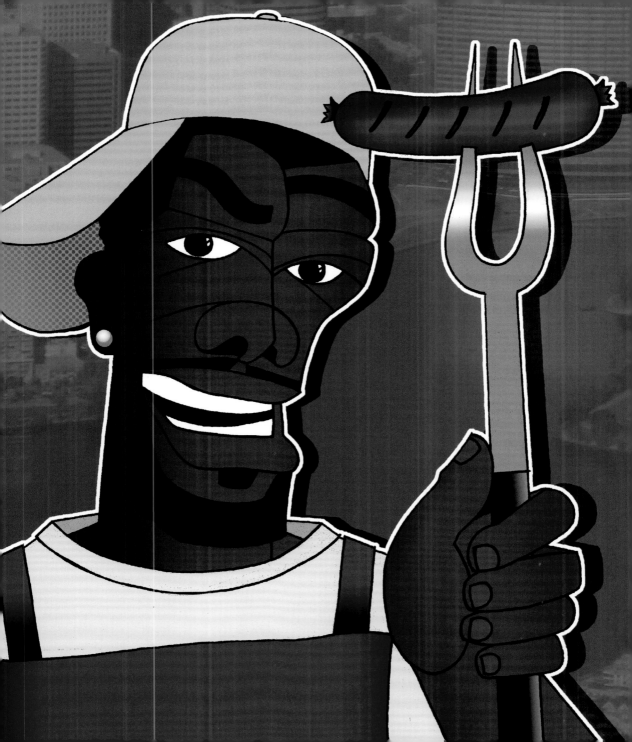

Being a Kid While Black

\ bē-iŋ ə kɪd wī(-ə)l blak \

1) A phrase describing the characterization of Black children's age-appropriate behavior as aberrant, criminal, or monstrous by teachers, school administrators, or school counselors.

2) A reference to the criminalization of African American children's expressions of grief, anger, fear, or hurt.

3) A term applied to any incident in which law enforcement officers handcuff, arrest, or detain a Black child for minor acts of defiance.

abbrev. None in use

Biking While Black

\ bīk-iŋ wī(-ə)l blak \

1) A term applied to incidents in which Black bicyclists are subjected to enhanced scrutiny, harassment, or threat of arrest by law enforcement or vigilantes, especially in communities with very few Black residents.

2) A reference to Black cyclists' subjection to rarely enforced, obscure, or fabricated laws and regulations by police.

abbrev. BWB

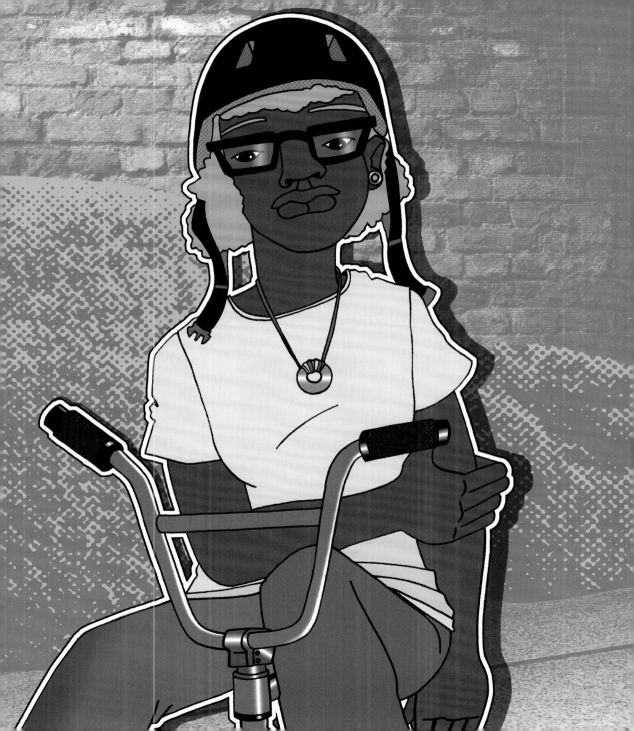

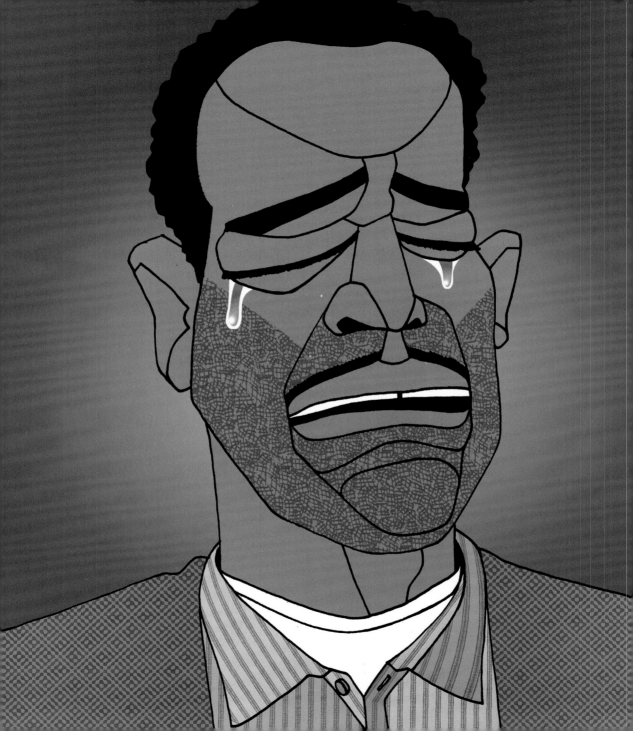

Crying While Black

\ krī-iŋ wī(-ə)l blak \

1) A reference to the arrest of a Black person for crying in a setting or at a volume that a police officer or officer of the court finds unacceptable.

2) An act of resistance; the clearest and most unequivocal expression that everything— racism, inequality, injustice—is, in fact, not fine.

abbrev. CWB

Dancing While Black

\ dæns-iŋ wī(-ə)l blak \

1) A reference to Black activists' use of movement and joy to highlight and oppose policies and systems that seek to restrict the rights and freedoms of people of African descent.

2) A phrase applied to the detainment and arrest of one or more Black people for dancing in a setting in which Black energy, pleasure, and expression are perceived as threatening or inappropriate.

abbrev. DWB

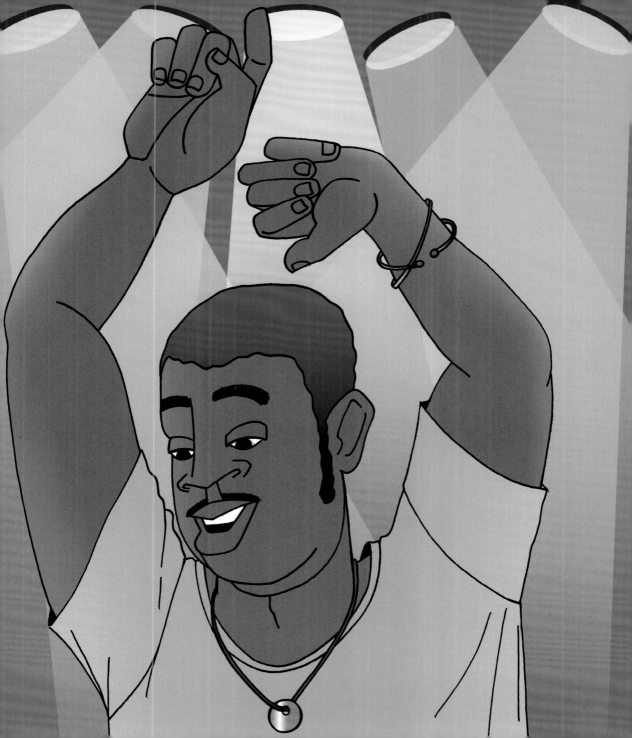

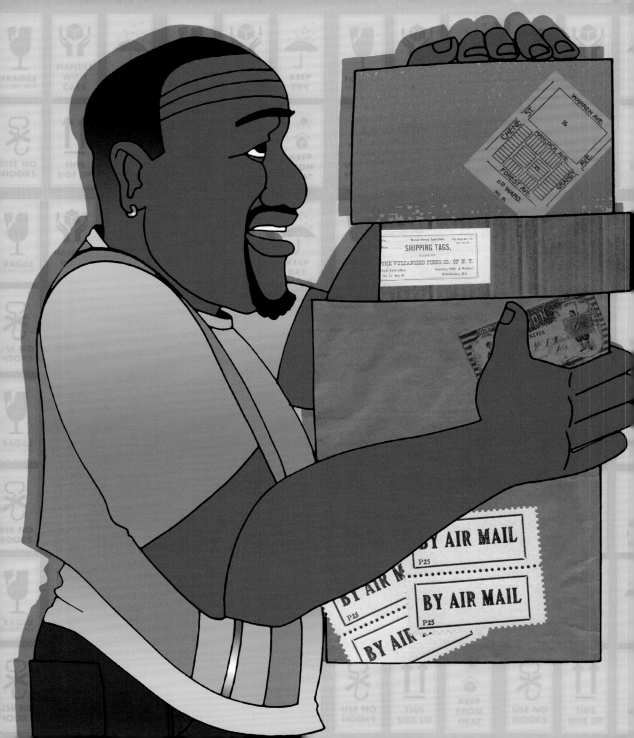

Delivery While Black

\ də-liv-(ə)-rē wī(-ə)l blak \

1) A term that applies to the harassment of Black delivery drivers, mail carriers, and newspaper carriers by neighborhood residents, most often in communities with few Black residents.

2) A reference to any occasion in which community members report a Black mail carrier, newspaper carrier, or other delivery professional to local law enforcement simply for doing their job.

abbrev. None in use

Driving While Black

\ drīv-iŋ wī(-ə)l blak \

1) A cynical reference to incidents in which African American and other Black drivers are subject to enhanced scrutiny by law enforcement when passing through neighborhoods in which few Black people live and work.

2) A cynical reference to incidents in which African American and other Black drivers are subject to enhanced scrutiny by law enforcement when passing through neighborhoods in which large numbers of Black people live and work.

abbrev. DWB

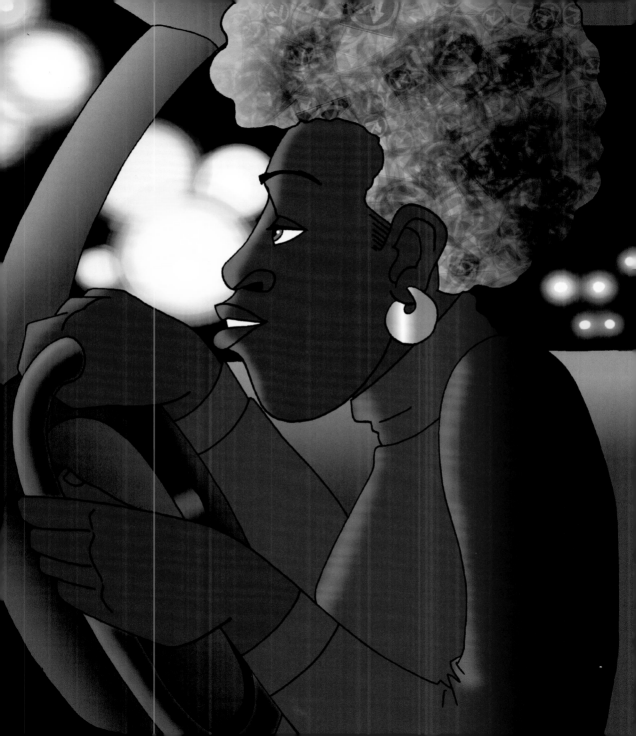

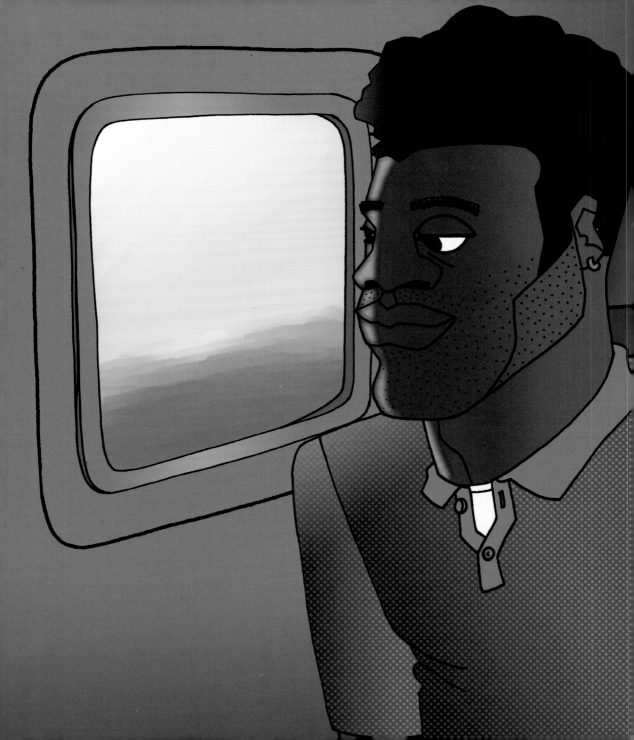

Flying While Black

\ flī-iŋ wī(-ə)l blak \

1) A term describing Black air travelers' subjec-
 tion to excessive searches and fees, refusal of
 passage, arrest upon landing, or other humil-
 iations for behaviors regarded as unremark-
 able for passengers who are not Black.

2) The pattern of bias against Black airline pas-
 sengers, the severity of which led the NAACP
 to issue a first-of-its-kind travel advisory
 against American Airlines for nine months,
 from October 2017 to July 2018.

abbrev. FWB

Going Home While Black

\ gō-iŋ hōm wī(-ə)l blak \

1) A reference to any incident in which a Black person is injured, detained, arrested, or killed by police or other law enforcement officers for attempting to enter their own home.

2) A phrase that describes any occasion in which a person who is not Black questions, refuses entry to, or calls the police on a Black person who is trying to enter the apartment building, gated community, or home in which they live.

abbrev. None in use

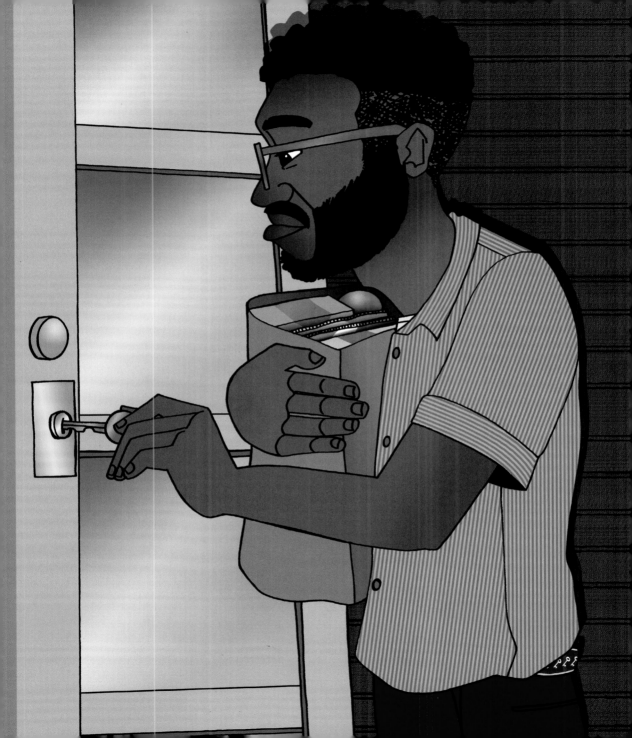

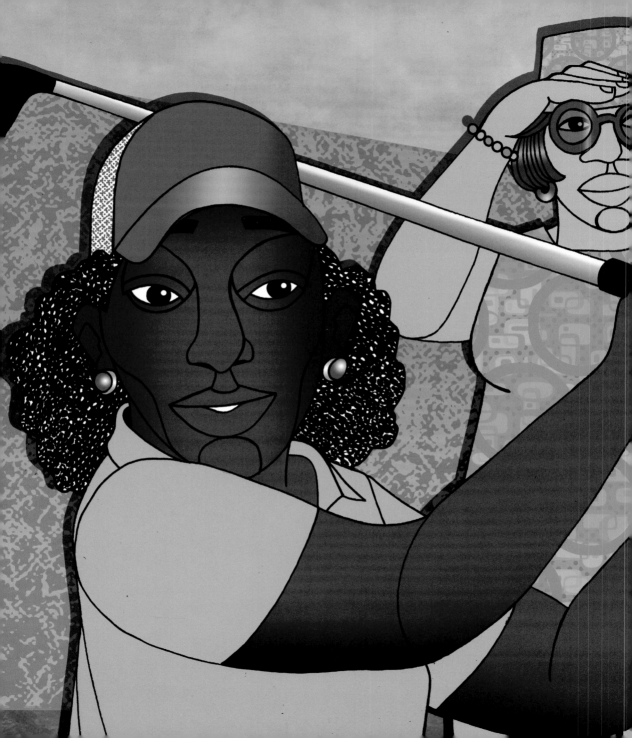

Golfing While Black

\ gälf-iŋ wī(-ə)l blak \

1) A phrase that applies to the suspicion that Black players often confront on both public and private golf courses.

2) A reference to the 2018 incident in which a group of Black women golfers in York, Pennsylvania, were reported to local police for playing too slowly.

abbrev. GWB

Grieving While Black

\ grēv-iŋ wī(-ə)l blak \

1) A reference to the detainment or arrest of Black mourners at a funeral, memorial site, or vigil.

2) A phrase applied to any encounter between mourners of African descent and white civilians or police officers who are indifferent to their grief.

abbrev. None in use

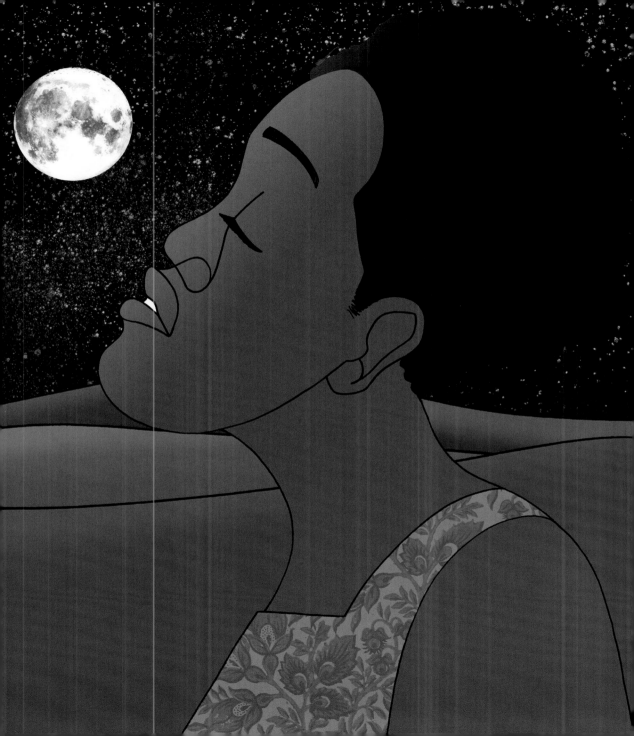

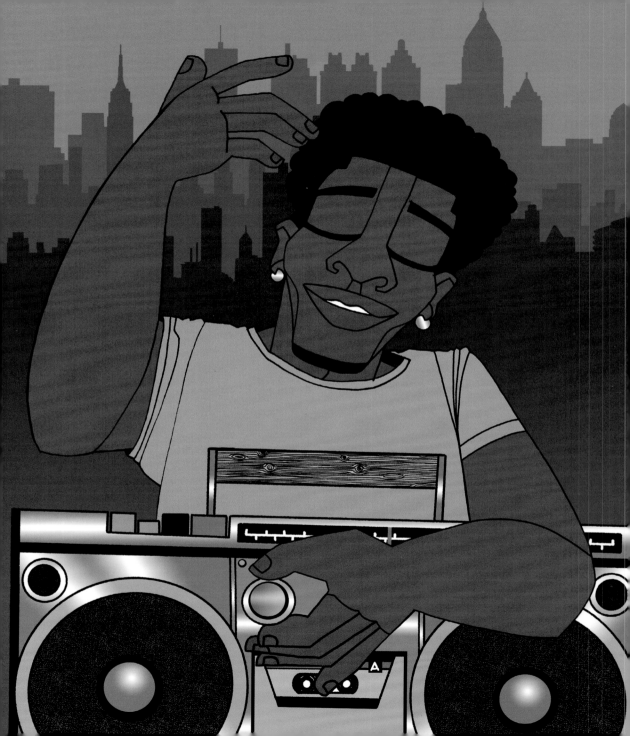

Jamming While Black

\ jæm-iŋ wī(-ə)l blak \

1) A label applied to any incident in which Black people are reported to law enforcement for listening to music.

2) A reference to the hostile and sometimes violent reaction of non-Black people to African American recorded music played at a high volume, most frequently in response to hip-hop and rap played by African American youth.

3) The use of Black recorded music, played loudly in a public setting, to claim space for, call attention to, or assert the presence of African American people and culture, especially in predominantly white environments.

abbrev. None in use

Jogging While Black

\ jŏg-iŋ wī(-ə)l blak \

1) A reference to the harassment, arrest, and violence experienced by Black recreational runners for the perceived crime of jogging through predominantly white neighborhoods.

2) The pedestrian counterpart of Driving While Black.

abbrev. JWB

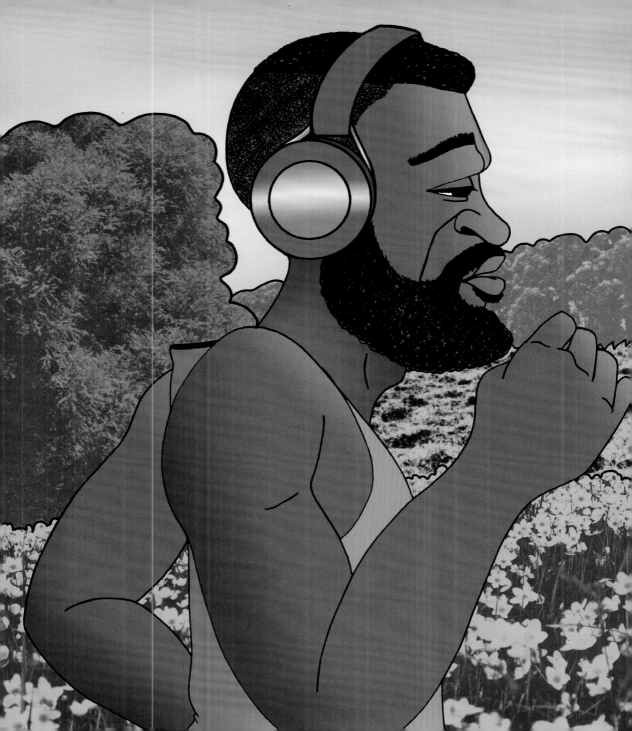

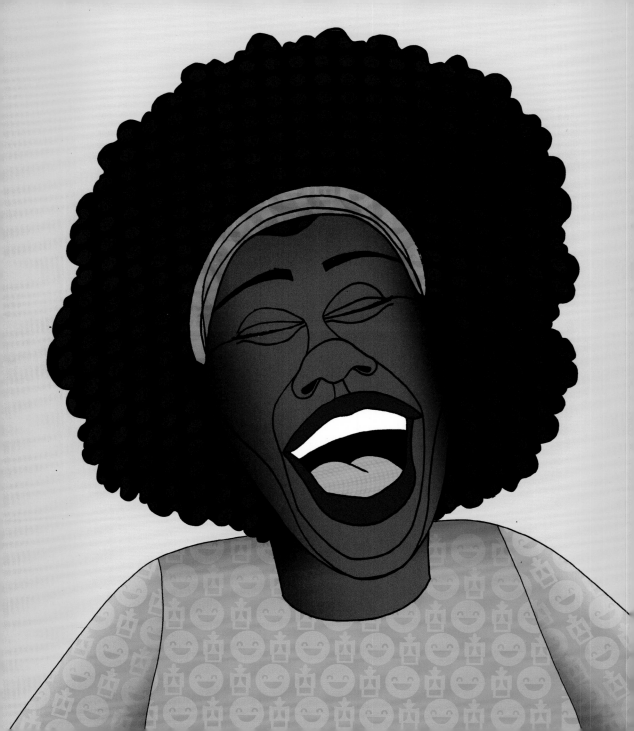

Laughing While Black

\ läf-iŋ wī(-ə)l blak \

1) A phrase that describes the treatment of Black joy and laughter with hostility, suspicion, or contempt.

2) A sardonic reference to instances in which a Black individual or group is confronted, harassed, or removed from an establishment because their laughter offends the non-Black patrons around them.

3) The arrest or detainment of a Black individual or group whose laughter is perceived as excessive, inappropriate, or unruly.

abbrev. None in use

Lodging While Black

\ lɑdʒ-iŋ wī(-ə)l blak \

1) A phrase that applies to the harassment, arrest, or eviction of registered Black guests from hotels, motels, and other accommodations.

2) A reference to any incident in which hotel or motel staff report registered Black guests to private security or local police on suspicion of trespassing.

abbrev. None in use

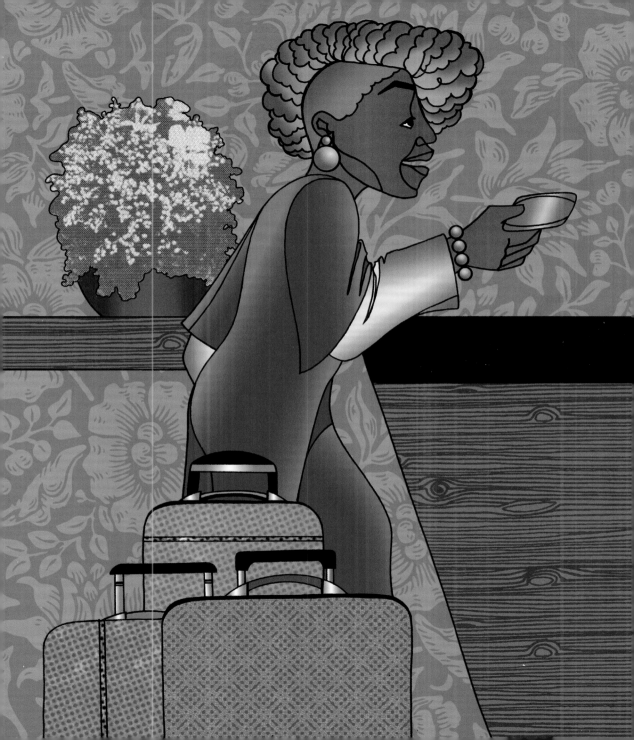

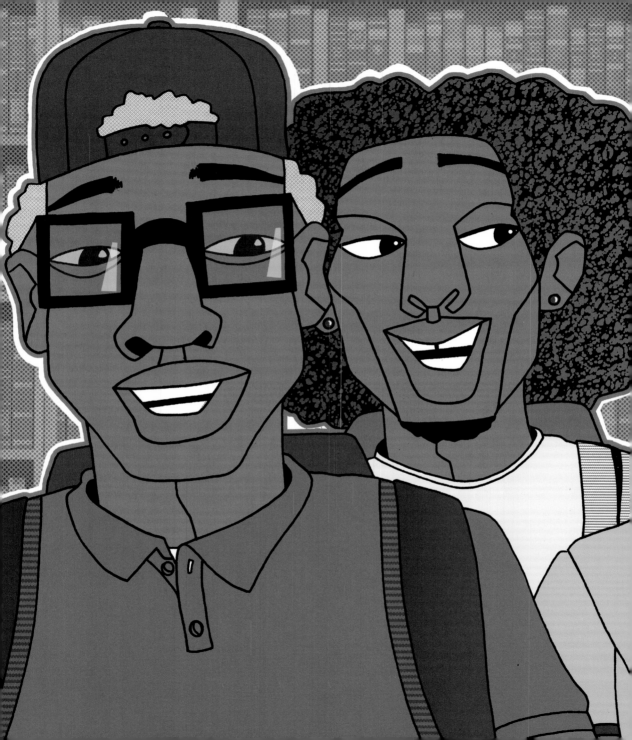

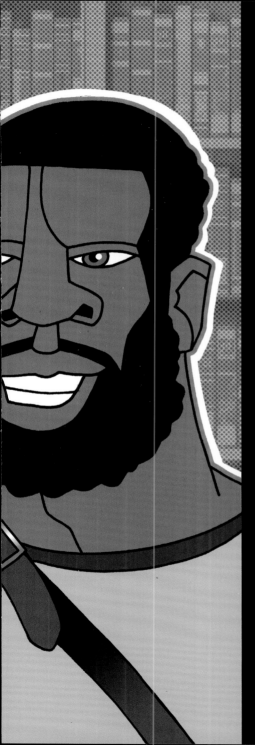

On Campus While Black

\ ôn kæm-pəs wī(-ə)l blak \

1) A reference to any incident in which a member of a college or university campus community reports a Black student, staff member, faculty member, or guest to campus police or security on suspicion of trespassing.

2) A phrase that applies to the hostility, microaggressions, and harassment experienced by Black students on many predominantly white campuses.

abbrev. None in use

Parenting While Black

\ pæ-rən(t)-iŋ wī(-ə)l blak \

1) A term that applies to the disproportionate level of scrutiny applied to Black parents by social services agencies, law enforcement, and non-Black neighbors.

2) A reference to the treatment of and punitive actions taken against Black parents, especially single mothers, and their children by police, school administrators, teachers, and social services agencies.

3) A reference to any incident in which neighbors, teachers, or other community members call police to report a Black parent for activities considered acceptable when carried out by white parents.

abbrev. PWB

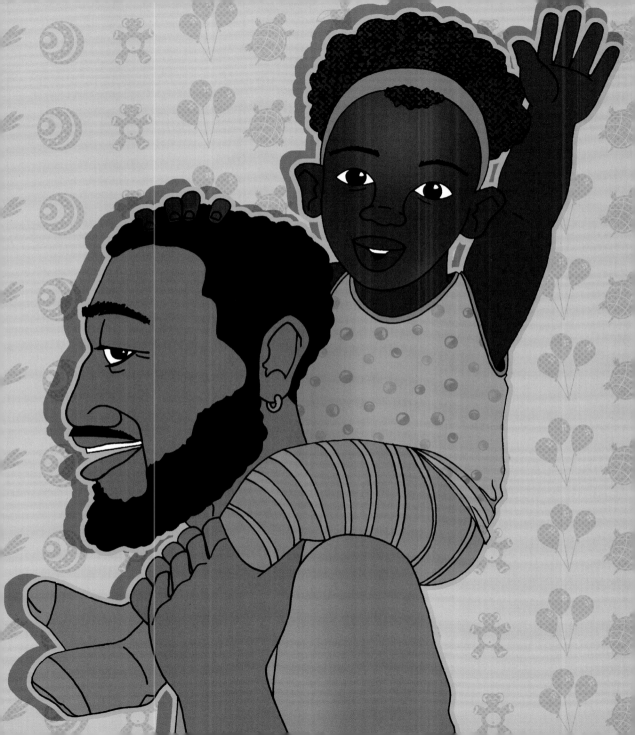

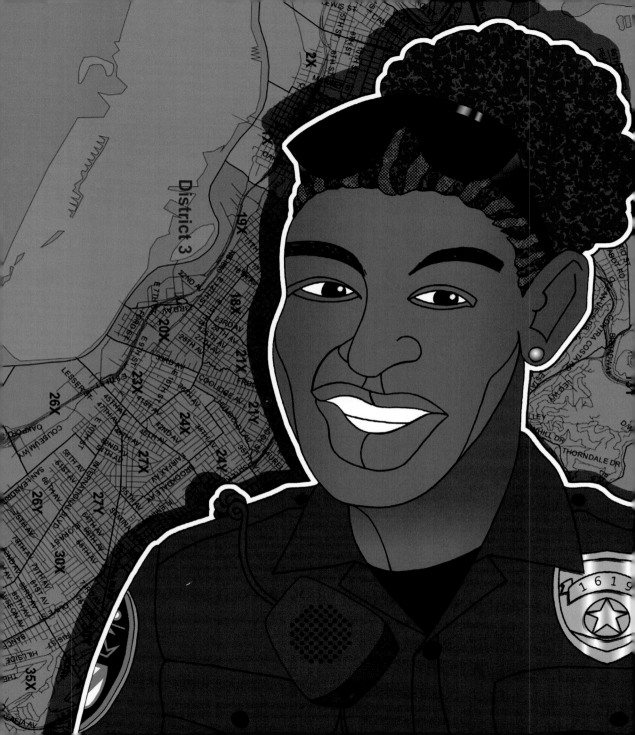

Policing While Black

\ pə-lēs-iŋ wī(-ə)l blak \

1) A label applied to incidents in which off-duty or plainclothes Black law enforcement officers are profiled, beaten, or killed by one or more of their white colleagues.

2) A reference to encounters in which white police officers regard off-duty or plainclothes Black officers with the same suspicion and contempt as Black civilians.

abbrev. None in use

Praying While Black

\ prā-iŋ wī(-ə)l blak \

1) A label applied to incidents that highlight police officers' and non-Black civilians' disregard for the sanctity of the spaces, activities, and moments that Black people have set aside for religious gatherings, sacred rituals, and prayer.

2) A reference to the 2015 mass killing of nine Black worshippers at the Mother Emanuel AME Church in Charleston, South Carolina, by a white supremacist gunman.

abbrev. None in use

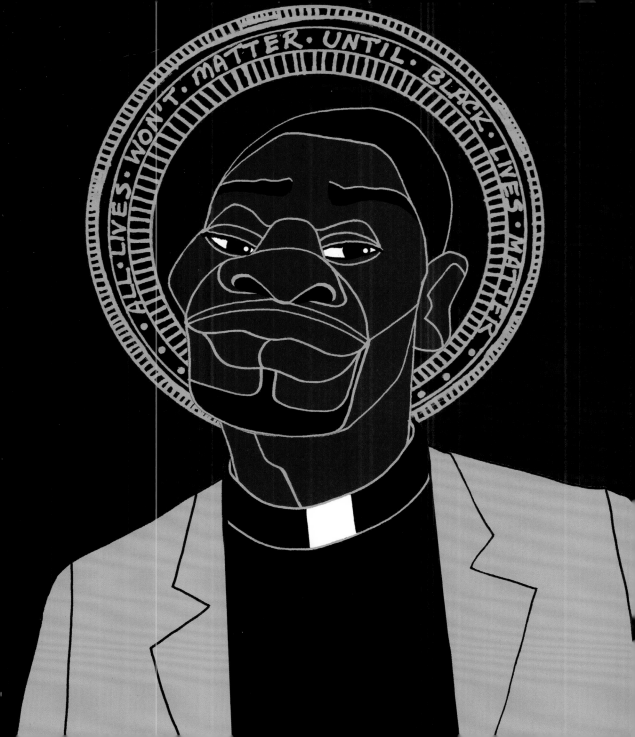

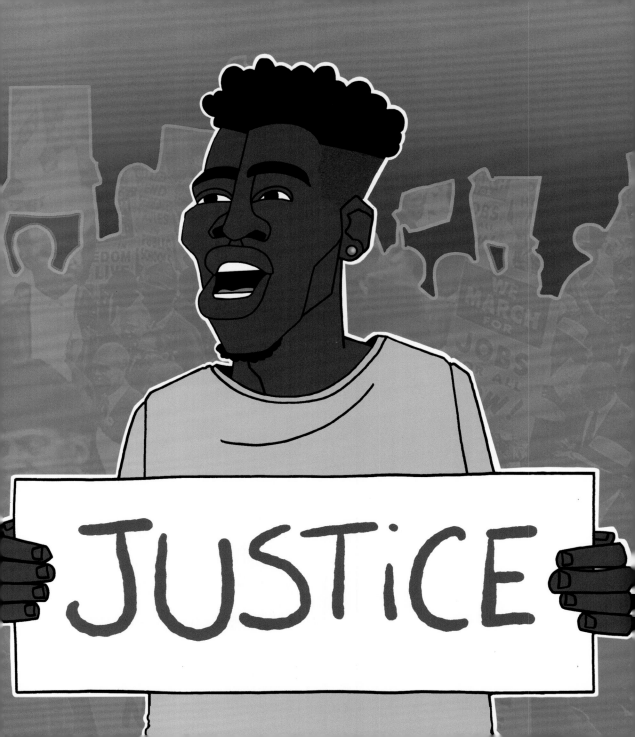

Protesting While Black

\ prō-tɛst-iŋ wī(-ə)l blak \

1) A label applied to the harassment, intimidation, beating, and arrest of Black groups and individuals involved in peaceful protest.

2) An expression of the irony inherent in the criminalization of protest when carried out by an ethnic group whose core liberation movement is built on a foundation of non-violent resistance.

abbrev. PWB

Running While Black

\ rən-iŋ wī(-ə)l blak \

1) A phrase that describes a Black person's flight, on foot, from police officers in pursuit. It is distinguished from Jogging While Black by its urgency and non-recreational function.

2) A reference to law enforcement officers' fatal shooting of Black suspects who are in retreat.

3) The use of deadly force against a fleeing suspect who poses a threat neither to the arresting officer nor to bystanders. Such force was ruled unconstitutional in the 1985 Supreme Court decision *Tennessee v. Garner.*

4) The only Living While Black offense that is regarded as a crime in most jurisdictions, though it is rarely fatal for white perpetrators.

abbrev. RWB

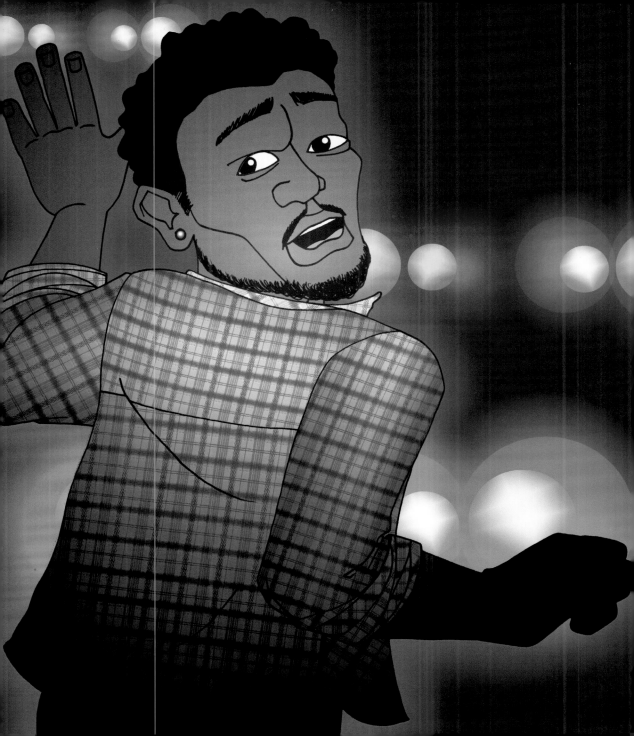

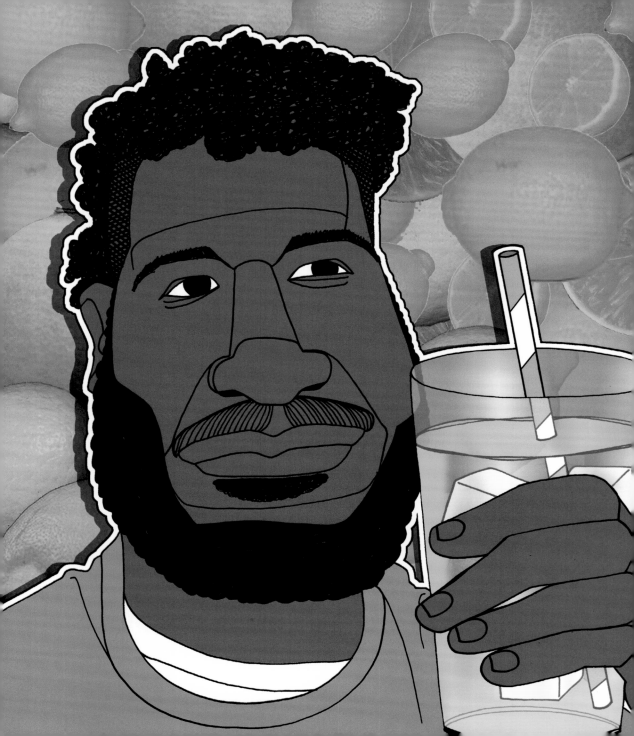

Selling Lemonade While Black

\ sɛl-iŋ lɛ-mə-nād wī(-ə)l blak \

1) A term that refers to any occasion in which neighbors or other community members call police to report a Black child or children for operating a lemonade stand.

2) A reference to the July 2018 incident in which a Black shop owner in San Francisco was questioned by police officers after an anonymous 911 caller reported him for unlocking the door of his own lemonade store.

abbrev. None in use

Selling Water While Black

\ sɛl-iŋ wô-dər wī(-ə)l blak \

1) A reference to the June 2018 incident in
 which a white woman called police to report
 an eight-year-old Black girl for selling bottles
 of water without a permit in San Francisco.

abbrev. None in use

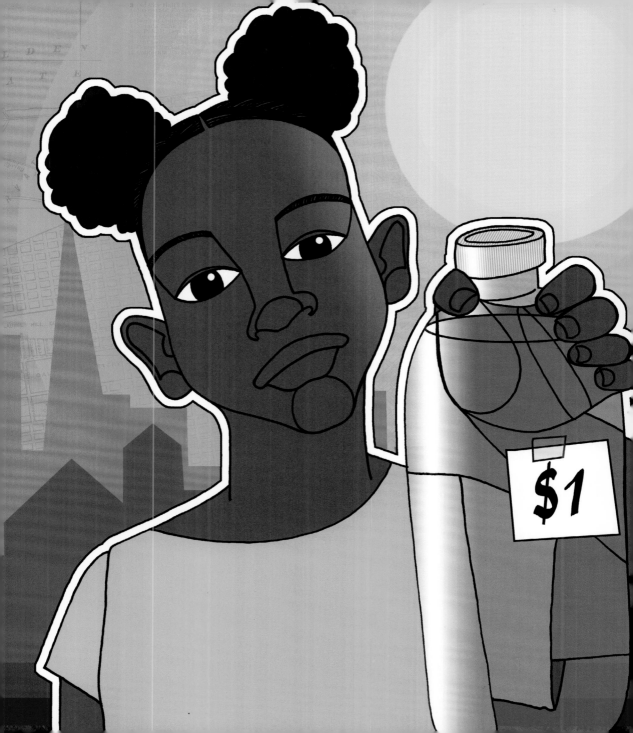

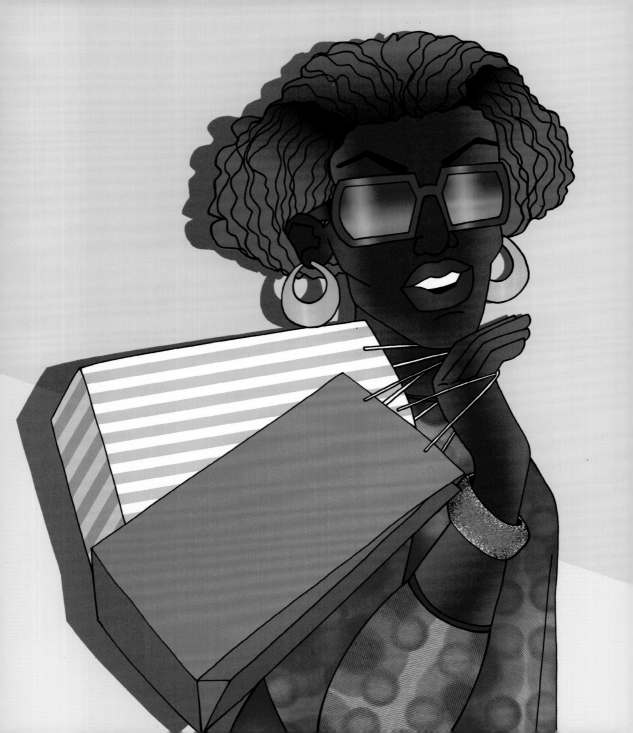

Shopping While Black

\ shŏp-iŋ wī(-ə)l blak \

1) A label applied to a range of actions taken by retail employees to disparage, demoralize, or otherwise discourage Black shoppers.

2) A reference to the profiling and accusation of Black patrons as shoplifters, loiterers, or vandals.

3) A phrase that describes any refusal of service to a Black patron seeking to enter a luxury shop or boutique.

abbrev. None in use

Singing While Black

\ sɪŋ-ɪŋ wī(-ə)l blak \

1) A phrase that refers to the treatment of Black expression through song as nuisance, disturbance, or noise.

2) A reference to instances in which Black individuals or groups are questioned, arrested, or fined for singing at a volume at which their voices are audible to neighbors in the surrounding area.

abbrev. SWB

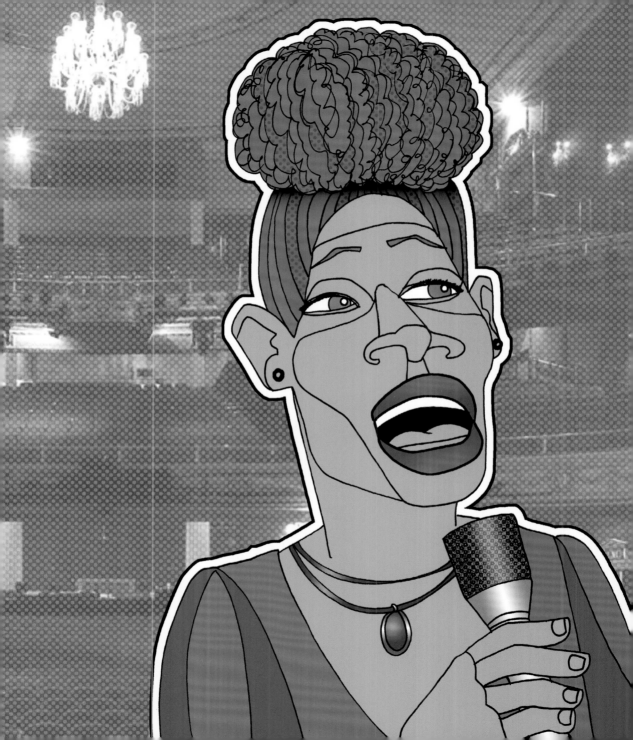

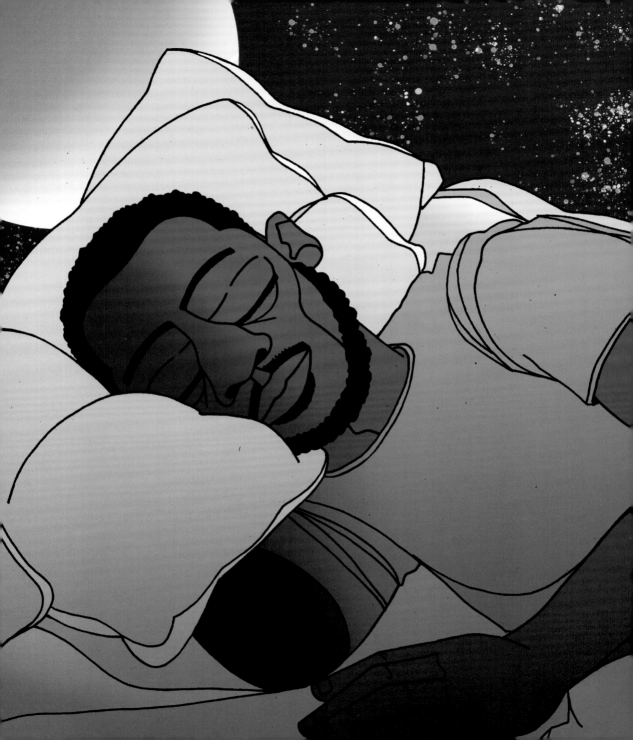

Sleeping While Black

\ slēp-iŋ wī(-ə)l blak \

1) A reference to the stigmatization of public sleeping by Black people in settings in which sleeping by white people is either permitted or overlooked.

2) A cynical reference to any instance in which Black people are injured, arrested or killed by law enforcement officers during raids on their homes carried out while they are in bed, asleep, or both.

3) A phrase that applies to any incident in which a Black person who is asleep or unconscious in their vehicle is surrounded by police officers and shot and killed immediately upon waking.

abbrev. SWB

Smoking While Black

\ smōk-iŋ wī(-ə)l blak \

1) A reference to the questioning, reporting, or arrest of a Black person for smoking a cigarette, cigar, or tobacco pipe in a lawful smoking area.

2) A phrase that applies to police officers' use of anti-smoking regulations as a basis for questioning, searching, or arresting people of African descent.

abbrev. SWB

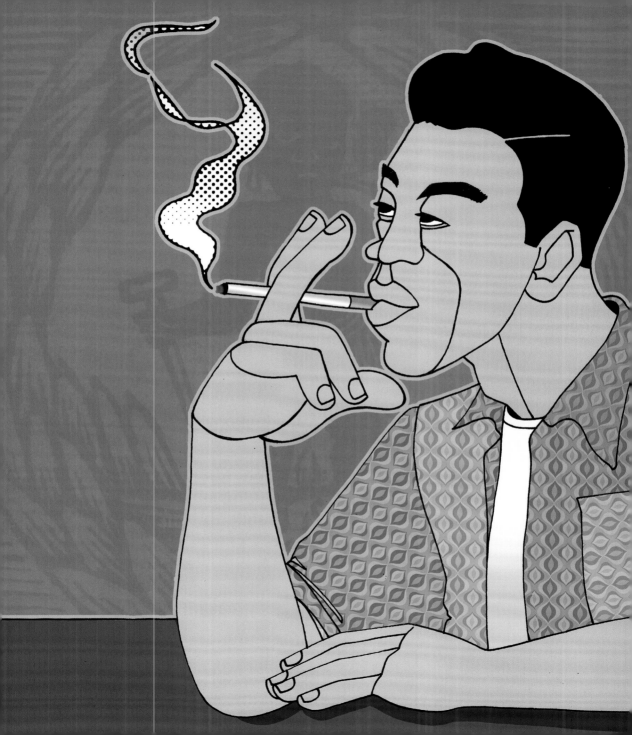

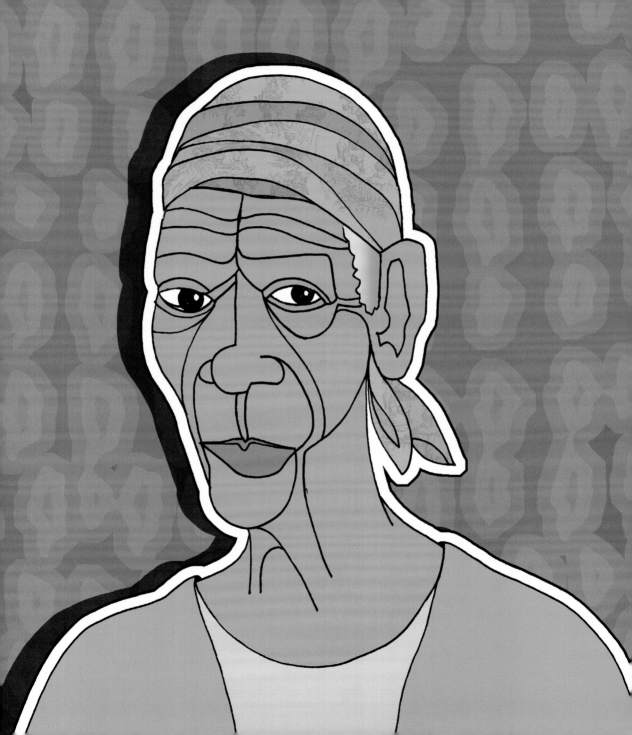

Staring While Black

\ stɛr-iŋ wī(-ə)l blak \

1) A reference to the questioning, detainment, or arrest of a Black person for glaring at a police officer.

2) A phrase that describes any incident in which a non-Black person calls security, law enforcement, or another authority figure to report that a Black person has stared at them.

3) The historical criminalization of the Black gaze on white people, most often the Black male gaze on white women, also known by its historic label, *reckless eyeballing*.

abbrev. None in use

Studying While Black

\ stəd-ē-iŋ wī(-ə)l blak \

1) A reference to the harassment, questioning, removal, or arrest of Black people attempting to use or access libraries and library materials.

2) A name for any incident in which library patrons or staff regard the presence of patrons of African descent as suspicious.

3) A term applied to the harassment, question-ing, arrest, or removal of Black students and faculty from designated study areas on col-lege and university campuses. *See also* On Campus While Black.

abbrev. **SWB**

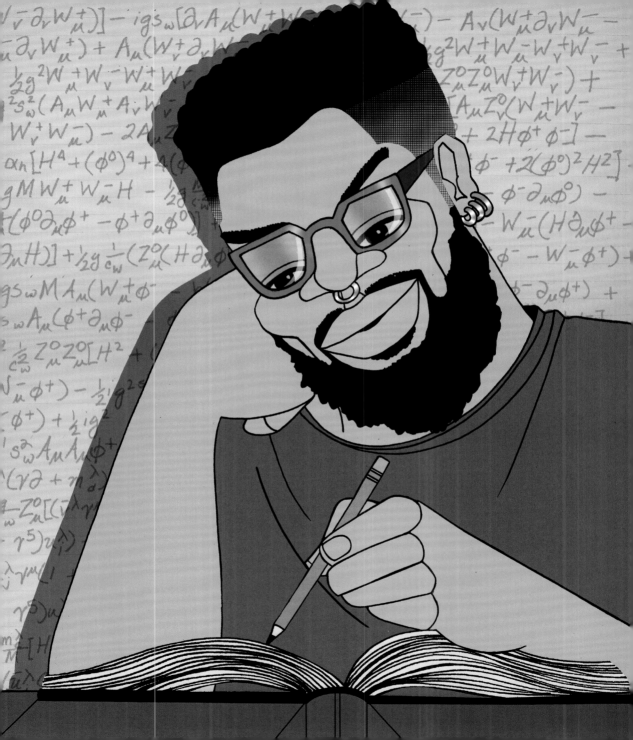

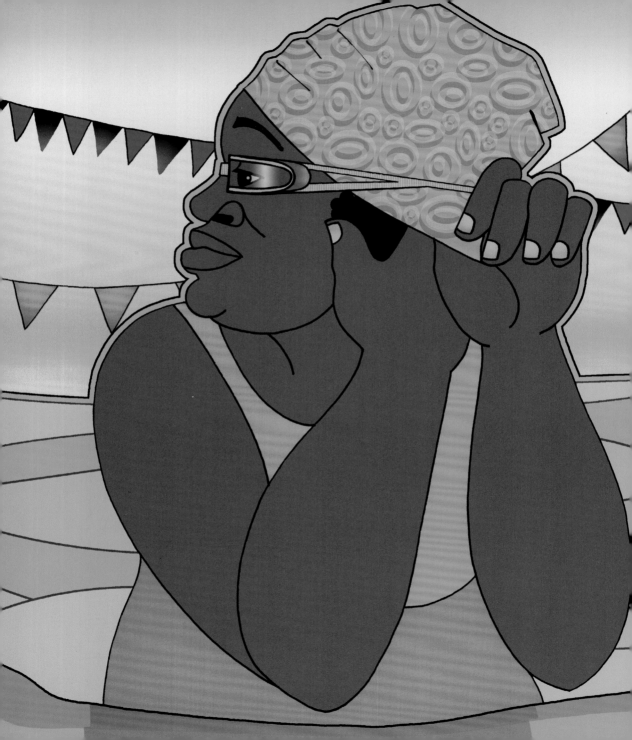

Swimming While Black

/swim - iŋ – wī(-ə)l – blak/

1) A term for the historic resistance to Black people's equal access to swimming pools and beaches, throughout the United States and worldwide.

2) A phrase that describes any incident in which Black people's right of access to a public or residential pool is questioned or denied.

abbrev. **SWB**

Thinking While Black

\ thɪŋk-iŋ wī(-ə)l blak \

1) A label applied to the questioning, harass-
 ment, or arrest of Black people for sitting
 silently and unoccupied in a public setting.

2) A reference to the fate of Black college and
 university professors whose anti-racist writ-
 ings in academic publications, in mainstream
 periodicals, or on social media jeopardize
 their access to promotions, tenure, or future
 employment.

abbrev. TWB

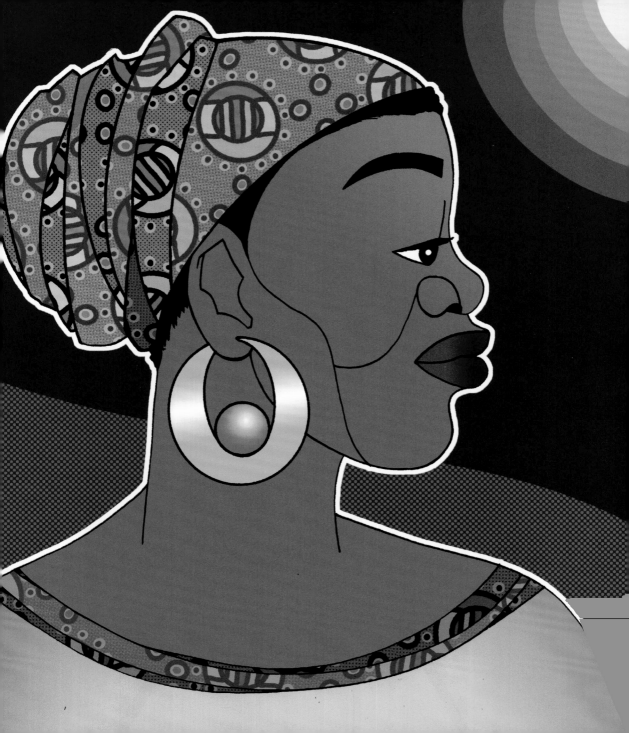

Trans While Black

\ trænz wī(-ə)l blak \

1) A reference to the targeting of Black trans people for harassment, abuse, or arrest by law enforcement officers.

2) A reference to the use of anti-loitering laws to criminalize Black trans people, usually Black trans women.

3) A phrase that describes the muted response of law enforcement to crimes against Black trans women, a demographic that experiences disproportionate levels of intimate partner violence, sometimes resulting in death.

abbrev. TWB

Voting While Black

\ vōt-iŋ wī(-ə)l blak \

1) A cynical reference to past and present efforts to limit African American voter partici-pation, from nineteenth-century poll taxes to twenty-first-century poll watchers.

2) A phrase associated with enhanced scrutiny of Black voter signatures, more stringent ID requirements, the closure of polling places in Black neighborhoods, and other measures undertaken to decrease the size and impact of the African American vote.

abbrev. VWB

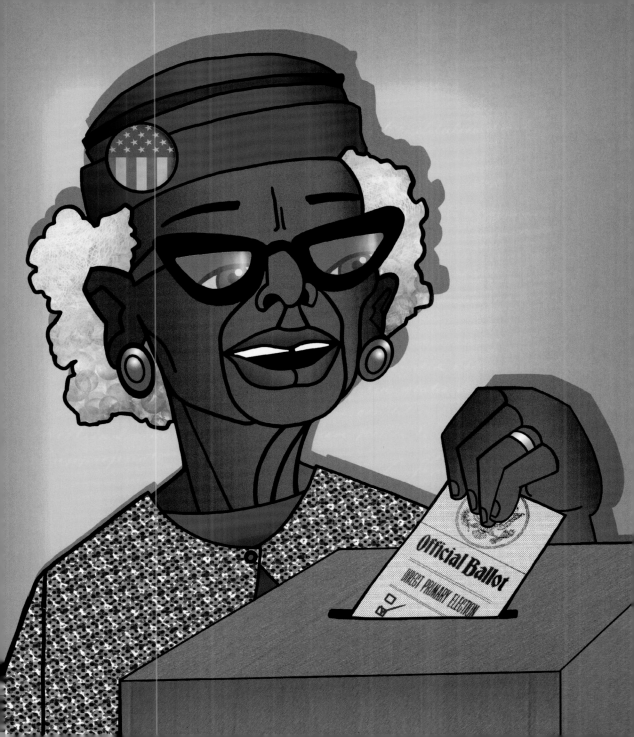

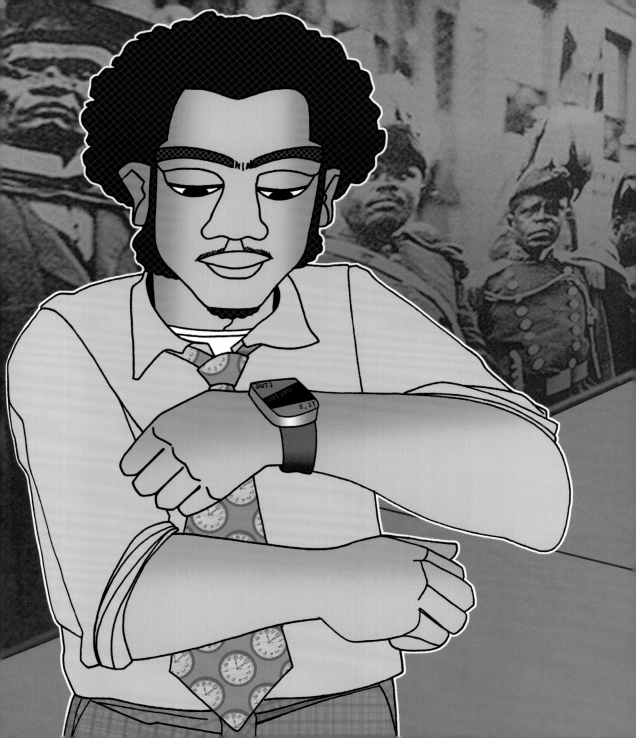

Waiting While Black

\ wāt-iŋ wī(-ə)l blak \

1) A reference to the treatment of Black people with suspicion for waiting, most often in public settings in which waiting is common and expected, especially in predominantly white neighborhoods and gathering places.

2) A label that applies to any incident in which employees, neighbors, or other bystanders call police to report Black people for waiting, especially in public settings in which waiting is common and expected.

abbrev. None in use

Wearing a Beanie While Black

\ wer-iŋ ə bē-nē wī(-ə)l blak \

1) A label applied to efforts by US law enforce-
 ment to criminalize beanies and other cloth-
 ing items popular among Black youth, under
 the pretext of gang intervention and urban
 crime prevention.

2) A phrase that calls attention to the gap
 between how a beanie is perceived when
 worn by a white person (as protection from
 the cold or as an indicator of political, creative,
 or social progressivism) and how the same
 piece of clothing is interpreted when it is worn
 by someone who is Black (as gang attire).

abbrev. None in use

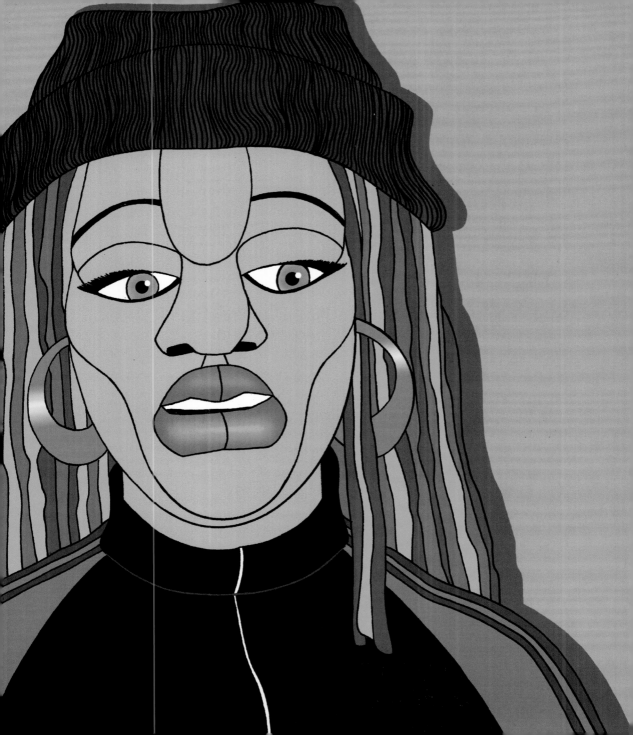

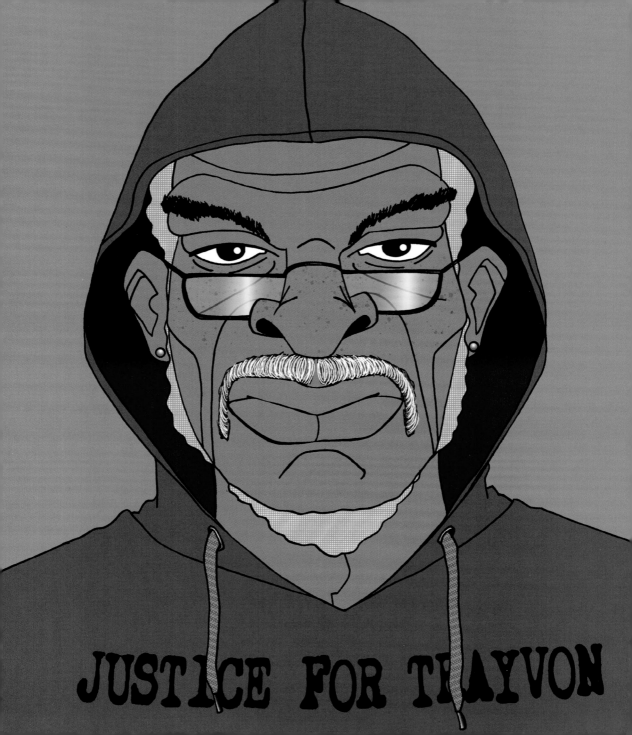

Wearing a Hoodie While Black

\ wer-iŋ ə hu-dē wī(-ə)l blak \

1) A label applied to efforts by US law enforcement to criminalize hoodies and other clothing items popular among Black youth, under the pretext of gang intervention and violence reduction.

2) A reference to the 2012 shooting death of Trayvon Martin, an unarmed Black teenager who was wearing a hoodie when he was killed by a neighborhood vigilante, and to efforts to ascribe his death to his style of dress.

3) A phrase that calls attention to the gap between how a hoodie is perceived when worn by a white person (as an indicator of social, athletic, and intellectual fitness) and how the same piece of clothing is interpreted when it is worn by someone who is Black (as gang attire).

abbrev. None in use

Working Out While Black

\ wərk-iŋ aůt wī(-ə)l blak \

1) A reference to the harassment, refusal of ser-
 vice, questioning, or arrest of a Black person
 at a private gym or health club.

2) A label applied to the treatment of a Black
 person who is working out, attending a fit-
 ness class, or otherwise using the facilities
 at a health club or gym as unwelcome or
 suspicious.

abbrev. None in use

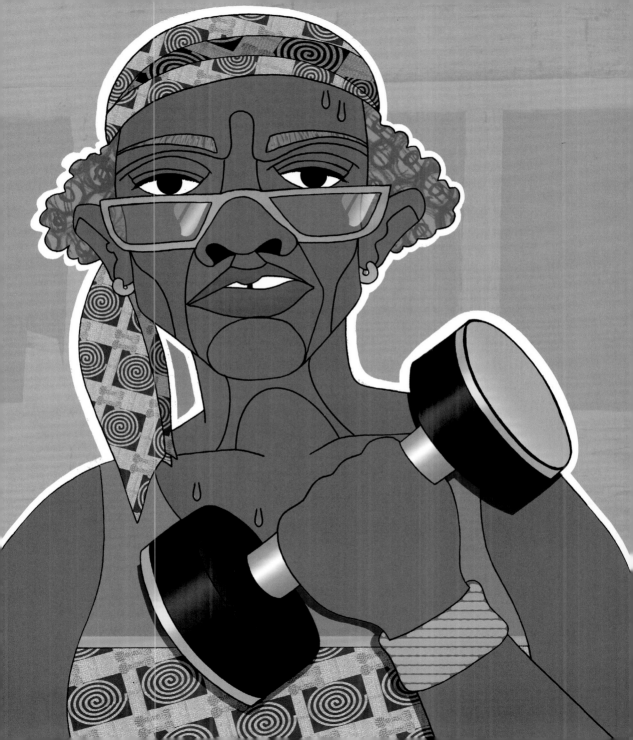

TIME LINE

LIVING WHILE BLACK IN THE TWENTY-FIRST CENTURY: A TIME LINE

The illustrations in this book were inspired by real-life incidents in which Black people were harassed, reported to police, arrested, or killed for either mundane activities or minor transgressions (childhood temper tantrums, using a cell phone in class, running from the police). The time line that follows is a partial list of those encounters, organized chronologically. Each entry on the time line includes the Living While Black activity to which it corresponds. Entries also include the location of the incident and, when available, the name of the Black person or people to whom the injustice occurred. I share the names of the Black victims, but not those of the perpetrators, regardless

of their race or ethnicity, so that here, as in the rest of the book, the focus is on Black people's daily experience of living under forms of suspicion and threat that few others face. This time line provides a reference for the illustrations and definitions in this book, but it also offers at least a partial snapshot of the criminalization of Black lives in the twenty-first century. While not exhaustive, the time line offers a sense of the breadth and depth of the problem as well as a glimpse into the devastation such incidents leave in their wake.

The time line begins in the year 2009 because that year marked a turning point in public awareness of Black people's mistreatment at the hands of both law enforcement officers and civilians. The year began with the killing of twenty-two-year-old Oscar Grant at the Fruitvale station of the Bay Area Rapid Transit (BART) commuter rail system in Oakland, California. Grant, a lifelong Bay Area resident, a father, and a butcher at my favorite local grocery, was unarmed and compliant when he was shot and killed by a transit officer in the wee hours of January 1. His death was captured on cell phones and other handheld devices, and some of the videos were shared through social media. This tragic event is believed to be the first instance of police brutality ever captured on cell phone video. We know Oscar Grant's name and the details of his last moments because of the bystander video that was recorded and circulated by witnesses.

Since Grant's death, both the number and the distribution of videos of civilian and police harassment and violence against Black people have grown. Today, even those incidents not captured on camera are more likely to be believed because

the wide dissemination of these recordings has helped establish that Black people's claims of police brutality and civilian harassment are real.

In terms of Black people's pursuit of core constitutional rights, then, the twenty-first century began not in 2001, but eight years later, on that tragic New Year's Day. In recognition of the divergent paces at which chronological time and racial justice time progress, the time line begins in early 2009, in memory of Oscar Grant and all of those whose last minutes, captured on bystander video, have moved nations and movements from anguish to outrage to action.

Note: A legend following the time line indicates the sources used in the collation of this material.

February 28 Parenting While Black (Boynton Beach, Florida): Police officers arrest Sharron Tasha Ford, thirty-four, for videorecording their interactions with her fifteen-year-old son.[1]

March 30 Driving While Black (San Francisco, California): Denise Green, forty-seven, is pulled over and held at gunpoint by police officers who mistakenly believe she is driving a stolen car.[12]

March 31 Aging While Black (Baltimore, Maryland): Barbara Floyd, fifty-eight, is standing outside her home, watching a law enforcement operation taking place down the street, when a police officer grabs her from behind, throws her to the ground, handcuffs her, and places her under arrest.[4]

May 28 Policing While Black (New York, New York): Off-duty officer Omar Edwards, twenty-five, is chasing a suspect in view of a police car when he is shot and killed by a white fellow officer.[10]

July 16 Going Home While Black, Attitude While Black (Cambridge, Massachusetts): Henry Louis Gates Jr., fifty-nine, is questioned by police officers responding to a call from a neighbor who observes Gates entering his home and believes he is a burglar. Officers handcuff and arrest Gates after he taunts them and accuses them of racial profiling.[10]

September 18 Going Home While Black (East Baltimore, Maryland): Expectant mother Starr Brown, twenty-six, returns home to see two girls being beaten by a large group of their peers. When Brown opens the door of her home to point responding officers in the direction of the assailants, they throw her to the ground, handcuff her, and arrest her.[4]

September 28 Being a Kid While Black (Syracuse, New York): Fifteen-year-old Andre Epps is tased, handcuffed, and arrested by police officers for attempting to break up a fight between two other students.[13]

October 3 Biking While Black, Running While Black (Pensacola, Florida): In the early hours of the morning, seventeen-year-old Victor Steen flees from police officers on his bicycle as they pursue him in their car, eventually hitting him, dragging him under their vehicle, and killing him.[6]

2010

February 20 Aging While Black (Homer, Louisiana): Seventy-three-year-old Bernard Monroe, whose throat cancer left him unable to speak, is shot and killed by police during an attempt to apprehend and question Monroe's adult son.[10]

May 16 Sleeping While Black (Detroit, Michigan): Just after midnight police officers conduct a raid on a home where seven-year-old Aiyana Stanley-Jones is asleep on the sofa. The officers, who are accompanied by a television crew, begin shooting upon entry, killing the child within seconds of their arrival.[14]

June 16 Being a Kid While Black, Biking While Black, Going Home While Black (Gainesville, Florida): Ten-year-old Bryce Bates is attacked by a police dog while riding his bicycle. Bates runs away on foot, calling for his mother, and the dog bites him just as he reaches his front door.[10]

July 5 Driving While Black (Miami, Florida): Police officers shoot and kill DeCarlos Moore, thirty-six, during a traffic stop based on

the unfounded suspicion that the unarmed Moore is operating a stolen vehicle. Moore is, in fact, driving his girlfriend's car.[8]

July 27 Sleeping While Black (Cincinnati, Ohio): Joann Burton, forty-eight, is asleep in Washington Park when a police officer runs over her in his patrol vehicle, killing her.[1]

August 6 On Campus While Black (Cincinnati, Ohio): In the early morning hours, University of Cincinnati police shoot eighteen-year-old Everette Howard, an unarmed Upward Bound student, with a Taser, causing him to suffer a fatal heart attack.[9]

August 22 Policing While Black (Queens, New York): Off-duty police officer Larry Jackson, thirty-nine, and his wife are hosting a birthday party for their daughter when an armed man arrives at their home. Jackson's wife calls 911 for assistance while Jackson removes the man from the premises. Responding officers choke, handcuff, and arrest Jackson.[9]

November 8 Running While Black (Oakland, California): Police officers responding to the report of a domestic dispute at a laundromat encounter local barber Derrick Jones, thirty-seven, who is unarmed. Jones flees from the officers, who shoot him twice with a Taser and then fire their guns multiple times, killing him.[12]

December 16 Being a Kid While Black (Salt Lake City, Utah): Police officers detain and question fourteen-year-old Kaleb Winston, accusing him of being a gang member based on graffiti-style drawings he made in his art class.[6]

2011

January 5 Aging While Black, Sleeping While Black (Framingham, Massachusetts): In the early morning hours, a SWAT team raids the home of sixty-eight-year-old Eurie Stamps, who is killed when an officer accidentally fires his weapon.[17]

January 19 Parenting While Black (Copley, Ohio): Single mother Kelley Williams-Bolar, forty-one, is sentenced to ten days in jail for sending her daughters to school in the wealthy Ohio district where their father and grandfather live.[10]

February 17 Shopping While Black, Being a Kid While Black (Stockton, California): Joseph Lee Green, sixteen, is beaten and arrested by an undercover police officer for attempting to buy candy at a service station convenience store.[8]

March 18 Driving While Black (Joliet, Illinois): Elijah Manuel, thirty-five, and his brother are pulled over by police officers who drag Manuel from the car, beat him, and arrest him for being in possession of a bottle of vitamins.[6]

June 5 Trans While Black (Minneapolis, Minnesota): Chrishaun "CeCe" McDonald, twenty-three, and several other young, Black, queer, or trans people and allies are attacked by three white, straight assailants. During the fight, she suffers a severe puncture wound and stabs one of the attackers to death. As

part of a plea agreement, McDonald is sentenced to serve forty-one months in a men's prison. She is released after nineteen months.[9]

June 15 Flying While Black (San Mateo County, California): Shortly before takeoff, twenty-year-old Deshon Marman, a University of New Mexico football player, is removed from his US Airways flight, arrested, and taken to jail for wearing sagging pajama pants that expose his boxer shorts.[12]

June 30 Flying While Black (Seattle, Washington): After successfully passing through TSA screening devices, thirty-year-old Laura Adiele is taken aside by an agent and told that her hair, worn naturally and without heat or chemical straighteners, necessitates an additional search by hand.[10]

November 19 Aging While Black (White Plains, New York): In the early morning hours sixty-eight-year-old Kenneth Chamberlain, a former Marine and corrections officer, accidentally sets off his medical alert necklace. Responding officers forcibly enter his residence, fire a Taser at Chamberlain, and then shoot him with a gun, causing fatal injuries.[16]

2012

February 2 Going Home While Black (Bronx, New York): An officer responding to a reported drug deal in progress pursues

eighteen-year-old Ramarley Graham into his family's home and follows him into a small bathroom, where the officer shoots the unarmed teenager and kills him.[10]

February 26 Wearing a Hoodie While Black (Sanford, Florida): In the early evening, while returning from a local convenience store, seventeen-year-old Trayvon Martin is killed by the neighborhood watch captain for the Twin Lakes community, where he is staying with his father. The assailant had previously placed a 911 call in which he described Martin as a suspicious person wearing a "dark hoodie."[14]

March 22 Laughing While Black (Chicago, Illinois): An off-duty police officer confronts and opens fire on a group of young adult friends laughing together in a city park, striking twenty-two-year-old Rekia Boyd in the back of her head and killing her.[6]

April 13 Running While Black (Wichita, Kansas): Police officers responding to a home where marijuana is being sold shoot and kill seventeen-year-old Timothy Collins Jr. as he flees the scene. Collins is unarmed.[5]

May 9 Driving While Black (Jacksonville, Florida): In the predawn hours, police officers pull over thirty-six-year-old Davinian Darnell Williams, who is unarmed, and fire six rounds into his stopped car, killing him at the scene.[1]

June 19 Crying While Black (Syracuse, New York): On his eighteenth birthday Trevon Hanks is tased, handcuffed, and arrested by

police officers as he lies crying in the hallway of Henninger High School. Hanks is distraught after having been told that he will not be able to complete the coursework necessary to graduate with his senior class.[13]

July 24 Running While Black (Dallas, Texas): Police officers responding to the false report of a kidnapping chase thirty-one-year-old James Harper as he flees the area on foot, eventually catching up with him, struggling with the unarmed man, and shooting him to death.[5]

July 25 Crying While Black, Shopping While Black, Being a Kid While Black (Saint Louis, Missouri): A police officer shoots twelve-year-old Dejamon Baker with a Taser as she cries while watching other officers arrest her mother while shopping at the South County Center mall.[9]

November 18 Running While Black (Waterloo, Iowa): In the early morning a police officer responding to reports of a man with a gun shoots twenty-two-year-old Derrick Ambrose Jr. in the back of the head and leg, killing him as he attempts to flee from officers on foot.[2]

December 15 Running While Black (Chicago, Illinois): Officers pursue Jamaal Moore, twenty-three, on suspicion that he has participated in a robbery. After Moore jumps from his SUV, police officers run over him in their vehicle, drag him under their car, and then shoot him in the back as he attempts to run away.[6]

2013

January 26 Jogging While Black (Braddock, Pennsylvania): The mayor of the small Pittsburgh suburb of Braddock calls police on a jogger, twenty-eight-year-old Christopher Miyares, and holds him at gunpoint until officers respond, question and search Miyares, and let him go.[10]

February 28 Shopping While Black (New York, New York): During an afternoon shopping trip, twenty-one-year-old nursing student Kayla Phillips is surrounded and questioned by four undercover police officers at Barneys department store after she purchased a $2,500 Celine bag using money from her federal tax refund.[9]

April 29 Shopping While Black (New York, New York): Trayon Christian, a nineteen-year-old college student, is accused of fraud, handcuffed, and arrested at Barneys after buying a $350 Salvatore Ferragamo belt with his own credit card.[9]

May 18 Biking While Black, Going Home While Black (South Los Angeles, California): After observing him riding a bicycle erratically and without a headlight or taillight, police pursue Terry Laffitte, forty-nine, to the backyard of his home, where a struggle ensues and officers kill the unarmed father of three.[7]

May 18 Selling Lemonade While Black, Being a Kid While Black (Indianapolis, Indiana): A lemonade stand run by ten-year-old

Morgen Morris at the Indianapolis Motor Speedway is shut down by a speedway employee for operating without a permit. The stand is part of the city's National Lemonade Day celebration and is sponsored by a local radio station.[16]

May 24 Parenting While Black, Grieving While Black (Fife, Washington): A SWAT team surrounds the home of thirty-year-old Leonard Thomas and kills him as he stands on his front porch holding his four-year-old son in his arms. The officers were responding to a report by Thomas's mother that the recent death of one of Thomas's friends may have left him too distraught to care for his son effectively.[3]

May 27 Staring While Black (Miami, Florida): On Memorial Day police officers approach and question fourteen-year-old Tremaine McMillian while he is playing at the beach. Officers tackle him, place him in a choke hold, and arrest him for glaring at them with "dehumanizing stares."[5]

June 8 Shopping While Black (New York, New York): After purchasing a $1,350 Movado watch at Macy's as a graduation gift for his mother, twenty-nine-year-old actor Rob Brown is surrounded by plainclothes police officers, handcuffed, and detained in a holding cell.[9]

June 16 Running While Black, Being a Kid While Black (Chicago, Illinois): Police officers responding to a report of gunfire shoot and kill fifteen-year-old Michael Westley as he flees from them on foot.[6]

July 28	Running While Black (Kansas City, Missouri): Early in the morning, a police officer shoots twenty-four-year-old Ryan Stokes, hitting him twice in the back and killing him as he attempts to escape on foot.[6]

2014

January 1	Trans While Black (New York, New York): Early on New Year's Day police officers arrest Shagasyia Diamond, thirty-six, and transport her to a local precinct where she is subjected to a strip search by a male officer and then confined in a holding cell with cisgender men.[10]
January 16	Biking While Black (Houston, Texas): Jordan Baker, twenty-six, is shot and killed by an off-duty police officer for riding his bike in a mall parking lot and looking into the windows of stores.[2]
March 30	Running While Black, On Campus While Black (Columbus, Georgia): Columbus State University police shoot and kill twenty-year-old Zikarious Flint as he flees on foot from officers responding to reports that he was loading a gun on the campus.[2]
June 15	Singing While Black (Gastonia, North Carolina): On Father's Day, Ronnie Gardin, forty, and Anissa Gardin, thirty-five, step out of their home to find police officers responding to reports of loud fighting in the street. The Gardins explain that they and

their children have been singing gospel music, but no one has been fighting. Both parents are handcuffed and questioned.[1]

June 29 Shopping While Black (Grosse Pointe, Michigan): Portia Roberson, forty-five, head of Detroit's Civil Rights and Justice Department, is shopping at the local Talbots store when two officers responding to a report of a theft question her, search her bags, and ask to review her receipt.[1]

July 9 Aging While Black (Seattle, Washington): A police officer pulls up to the corner where William Wingate, seventy, is preparing to walk across the street, demands that he drop the golf club that he uses as a cane, and then arrests him.[5]

August 5 Shopping While Black (Dayton, Ohio): Police responding to a 911 report of an armed man in a Walmart store shoot and kill twenty-two-year-old John Crawford III, who is holding a pellet gun he picked up in the toy department.[17]

September 13 Biking While Black, Running While Black (West Palm Beach, Florida): Dontrell Stephens, twenty, is riding his bicycle near the city center when a local deputy approaches him. Stephens flees on foot and is shot in the back when the officer mistakes his cell phone for a gun. The encounter leaves him paralyzed, and in 2021 Stephen dies from resulting complications.[5]

September 23 Being a Kid While Black (Houma, Louisiana): A police officer kills fourteen-year-old Cameron Tillman while responding to a 911 report of armed Black men entering an abandoned home

that local teens use as a hangout. Witnesses would later report that Tillman was unarmed.[9]

September 29 Praying While Black, Protesting While Black (Ferguson, Missouri): Rev. Osagyefo Sekou, forty-three, is arrested and detained by law enforcement officers for praying in the middle of an intersection while protesting the police killing of Michael Brown.[11]

November 22 Being a Kid While Black (Cleveland, Ohio): A police officer responding to a 911 report of a person pointing a gun outside a community recreation center kills twelve-year-old Tamir Rice, who was playing with an air pistol.[10]

2015

April 2 Running While Black (Tulsa, Oklahoma): Eric Courtney Harris, forty-four, is shot and killed by a volunteer "reserve" officer who mistakes his gun for his Taser as Harris flees during a foot pursuit.[17]

April 4 Running While Black, Driving While Black (North Charleston, South Carolina): A police officer stops Walter Scott, a fifty-year-old forklift operator, for driving with one of his brake lights out. Scott attempts to flee from the officer on foot, and the officer shoots him in the back, killing him.[10]

June 15	Driving While Black (Austin, Texas): Breaion King, a twenty-six-year-old elementary school teacher, is pulled over for speeding and then dragged from her car, slammed to the ground, handcuffed, arrested, and charged with resisting arrest.[17]
June 17	Praying While Black (Charleston, South Carolina): A white supremacist gunman kills nine members of the Mother Emanuel African Methodist Episcopal Church during an evening prayer meeting. The victims range in age from twenty-six to eighty-seven.[3]
July 10	Driving While Black, Smoking While Black, Attitude While Black (Prairie View, Texas): A local state trooper stops twenty-eight-year-old Sandra Bland for changing lanes without using a signal. After she declines to put out her cigarette or leave her vehicle, the officer forcibly removes her from her car, pushes her to the ground, and handcuffs and arrests her. She is held at the county jail where, three days later, she is found hanging in her cell. The death is ruled a suicide.[10]
July 13	Singing While Black, Praying While Black (Saint Louis, Missouri): Rev. Osagyefo Sekou, forty-four, is arrested while singing and praying in protest of the police shooting of sixteen-year-old Brandon Claxton.[11]
July 19	Driving While Black (Cincinnati, Ohio): A police officer shoots forty-three-year-old Samuel DuBose in the head during a traffic stop, killing the unarmed driver, despite his compliance with the officer's instructions.[2]

August 22	Laughing While Black (Napa, California): A group of ten African American women and one white woman, all members of the same Bay Area book club, are removed from the Napa Valley Wine Train for laughing too loudly.[12]
August 31	Singing While Black (Oakland, California): Pleasant Grove Baptist, a Black church in West Oakland, is served with a notice from the city's nuisance abatement division threatening steep fines for violating the local noise ordinance. The notice is sent in response to white neighbors' complaints about the volume of the church's choir rehearsals.[12]
October 12	Being a Kid While Black (Flint, Michigan): Police officers handcuff and detain seven-year-old Cameron McCadden, a student at an after-school program, for running around the bleachers and kicking a supply cart.[8]
October 19	Shopping While Black (Whitefish Bay, Wisconsin): NBA forward John Henson, twenty-five, and his three friends are refused service at the Schwanke-Kasten jewelry store. The men are later questioned by police officers responding to a 911 call from a shop employee who has reported them as suspicious.[5]
October 26	Being a Kid While Black (Columbia, South Carolina): A teacher at Spring Valley High School calls a school resource officer on a sixteen-year-old Black female student for refusing to give up her cell phone. The officer flips the student out of her desk and drags her across the classroom before handcuffing her and removing her from the area.[10]

October 26 Crying While Black (Columbia, South Carolina): A school resource officer arrests eighteen-year-old student Niya Kenny for crying and yelling at him while he drags and handcuffs a younger Black classmate.[15]

2016

February 13 Running While Black, Driving While Black (Beckville, Texas): Calin Roquemore, twenty-three, is shot and killed by a state trooper after tripping while fleeing from the officer on foot after a traffic stop.[1]

February 21 Sleeping While Black (Inglewood, California): Early in the morning police shoot and kill Kisha Michael, thirty-one, and Marquintan Sandlin, thirty-two, in the car in which the couple is sleeping.[7]

March 11 Laughing While Black (Saint Louis, Missouri): Activist Rodney Brown, twenty-nine, is arrested at a campaign rally for laughing at then presidential candidate Donald Trump.[13]

March 13 Policing While Black (Prince George's County, Maryland): Police Officer First Class Jacai Colson, twenty-eight, is shot and killed by a white officer who believes him to be an armed assailant.[17]

April 15 Being a Kid While Black (Murfreesboro, Tennessee): Police officers arrest four Black girls—one third grader, two fourth graders, and one sixth grader—at Hobgood Elementary School for failing to intervene in an off-campus fight between three boys.[2]

July 6 Driving While Black (Falcon Heights, Minnesota): Philando Castile, a thirty-two-year-old food services supervisor at the local Montessori school, is shot and killed by a police officer during a traffic stop for a nonfunctioning brake light.[17]

July 9 Protesting While Black (Baton Rouge, Louisiana): Police officers in riot gear arrest Ieshia Evans, thirty-five, for standing in the middle of the street at a protest against the murders of Alton Sterling and Philando Castile.[14]

July 26 Going Home While Black (Los Angeles, California): LAPD officers hold actor Ving Rhames, fifty-seven, at gunpoint in his own home in response to a white woman's false report that a large African American man is breaking into a neighbor's house.[7]

November 5 Grieving While Black (Chicago, Illinois): Joshua Beal, twenty-five, in town to attend his cousin's funeral, is killed during an altercation between his family and three white local residents—an off-duty firefighter and two off-duty police officers—one of whom is reported to have blocked at least two vehicles in the funeral procession.[6]

2017

February 21 Aging While Black, Sleeping While Black (Saint Louis, Missouri): A SWAT team executing a "no-knock" warrant kills Don Clark Sr., sixty-three, a retired Army veteran with limited hearing, sight, and mobility who was asleep when the team of seventeen officers entered his home.[11]

March 19 Sleeping While Black (Gifford, Florida): Alteria Woods, a twenty-one-year-old pharmacy technician, is killed during a predawn raid as SWAT team members enter through the window of the bedroom where she and her boyfriend are asleep.[17]

June 21 Policing While Black (Saint Louis, Missouri): Off-duty officer Milton Green, thirty-eight, is shot in the arm by a white colleague who believes him to be the suspect in an active police pursuit.[11]

July 7 Laughing While Black (Garfield Heights, Ohio): Robert Spencer, thirty, is arrested and later beaten by police officers for ridiculing and laughing at them as they passed through his neighborhood.[3]

September 17 Policing While Black (Saint Louis, Missouri): Detective Luther Hall, fifty-one, is beaten by three of his white colleagues while posing undercover as a Black Lives Matter protester.[11]

October 16 Aging While Black (Florence, South Carolina): Albert Chatfield, an eighty-six-year-old dementia patient, is tased by police officers as he backs away from them after a traffic stop.[1]

2018

February 24 On Campus While Black (New Haven, Connecticut): A white graduate student reports Yale Divinity student Reneson Jean-Louis, twenty-three, to campus police for asking her for directions to the dormitory common room.[2]

March 4 Waiting While Black, Lodging While Black (Richmond, Virginia): Forty-eight-year-old Albert Law, a software executive and registered guest, is waiting for a business associate in the lobby of the Hilton Richmond Downtown when a security officer approaches and asks him to verify that he is staying there.[16]

March 9 On Campus While Black (Cleveland, Ohio): Cleveland City Council member Kevin Conwell, fifty-eight, is confronted by Case Western Reserve University police officers responding to a report of a suspicious individual on campus.[2]

April 12 Waiting While Black (Philadelphia, Pennsylvania): Donte Robinson and Rashon Nelson, both twenty-three, are waiting at a Starbucks coffee shop for a third man to join them for a meeting when one of the employees calls police, who arrive in riot gear and escort the two men from the location.[17]

April 15 Working Out While Black (Secaucus, New Jersey): Police are called to LA Fitness by staff members who falsely accuse Tshyrad Oates, twenty-five, and friend Rachid Maiga, twenty-seven, of entering the gym without a valid membership.[3]

April 16 Working Out While Black (Charlotte, North Carolina): Staff at LA Fitness falsely accuse gym member Ralston Masaniai, a realtor in his thirties, of breaking into lockers and stealing credit cards.[3]

April 21 Golfing While Black (York, Pennsylvania): Police respond twice to reports by the co-owner of the Grandview Golf Club that Black club members Myneca Ojo, fifty-six, Sandra Thompson, fifty, Karen Crosby, fifty-eight, Sandra Harrison, fifty-nine, and Carolyn Dow, fifty-six, are golfing too slowly.[10]

April 29 Barbecuing While Black (Oakland, California): At Oakland's Lake Merritt, a white woman reports Kenzie Smith, thirty-seven, and Onsayo Abram, forty-two, to police for barbecuing with charcoal briquettes in an area designated for propane grilling.[12]

May 8 Sleeping While Black, On Campus While Black (New Haven, Connecticut): In the early morning hours Lolade Siyonbola, a thirty-four-year-old graduate student in African studies at Yale University, is questioned by campus police after being reported to officers by a white graduate student who found her napping in her dormitory lounge.[17]

June 18 Going Home While Black (Atlanta, Georgia): A white man positions his SUV at the entrance of the Buckhead Townhomes

to prevent Dr. Nnenna Aguocha, thirty-seven, a radiologist returning from the overnight shift at an area hospital, from reaching her home. Both call the local police, who allow Dr. Aguocha to pass into the gated community.[3]

June 24 Swimming While Black (Summerville, South Carolina): An adult white woman hits a fifteen-year-old Black boy in the face and chest and demands that he leave the community pool where he is swimming with his friends because "they did not belong" there.[17]

June 26 Grieving While Black (Charlotte Hall, Maryland): A white priest kicks a large gathering of Black mourners out of his church after one of the assembled accidentally knocks over and damages the church's chalice. He then calls local police, who are waiting outside the building when the mourners exit with the coffin.[17]

July 1 Smoking While Black (Atlanta, Georgia): Police respond to a white woman's report that an African American woman who lives in her apartment complex is smoking a cigarette in their shared parking structure.[3]

July 4 Swimming While Black (Winston-Salem, North Carolina): A white male volunteer at the community pool calls police after community resident Jasmine Abhulimen, forty-four, verifies her address but refuses his demand for further identification.[10]

July 6 Delivery While Black (Upper Arlington, Ohio): Police question eleven-year-old Uriah Sharp in response to a call from a white

neighbor who reports that the child's actions are suspicious. He is making deliveries on the first day of his paper route.[17]

September 4 Crying While Black (Cincinnati, Ohio): Kassandra Jackson is ordered to serve jail time for crying too loudly in the hallways of the Hamilton County Common Pleas Court.[8]

October 27 On Campus While Black (Richmond, Virginia): On a Thursday morning in mid-fall, a white professor observes visiting art professor Caitlin Cherry, thirty-one, eating breakfast in her classroom at Virginia Commonwealth University and reports her to campus security.[3]

November 3 Wearing a Hoodie While Black (Memphis, Tennessee): Mall security staff at Wolfchase Galleria follow a group of young Black men and remove them from the premises for wearing hoodies, which officers claim are in violation of the dress code. The mall code of conduct makes no mention of hoodies.[3]

December 22 Lodging While Black (Portland, Oregon): A white Hilton staff member accuses Jermaine Massey, thirty-five, a registered guest, of loitering in the hotel lobby and then calls police to escort him from the property.[17]

2019

April 25 Shopping While Black (Calabasas, California): During a spring shopping trip, recording artist SZA, twenty-nine, is questioned by security officers at Sephora after employees suspect her of stealing.[17]

May 14 Being a Kid While Black (Chevy Chase, Maryland): Officials at an elementary school call local police as well as the US Secret Service on the suspicion that a ten-year-old Black boy is attempting to pass the play money he brought to school as real currency.[17]

May 24 Trans While Black (Kansas City, Missouri): Breona "BB" Hill, thirty, has an altercation with another person in a beauty supply store and requests that the owner call police to the scene. Responding officers apprehend and beat Hill, who requires hospitalization for her injuries.[10]

May 31 Driving While Black, Aging While Black, Grieving While Black (Salisbury, North Carolina): Atlanta librarian Stephanie Bottom, sixty-eight, is pulled over by law enforcement officers on the way to her aunt's funeral. She suffers a torn rotator cuff when officers pull her by the hair and shoulder to remove her from her car.[17]

June 30 Flying While Black (Jamaica, West Indies): Before a flight home from Jamaica with her eight-year-old son, Latisha Rowe,

thirty-eight, a family medicine physician from Houston, is told by a Black flight attendant that she will not be permitted to board the plane if she does not cover her outfit, a brightly colored romper, with a coat or blanket.[10]

July 23　Swimming While Black (Hyattsville, Maryland): A white male resident confronts a group of Black women for having glassware in the pool area of their apartment complex and, after they comply with his request to stow their glassware, reports them to the complex leasing office and local police.[3]

August 24　Dancing While Black (Aurora, Colorado): An anonymous 911 caller reports twenty-three-year-old Elijah McClain for "looking sketchy" and waving his arms rhythmically. Responding officers restrain him with a choke hold, and paramedics inject him with heavy sedatives, causing him to go into cardiac arrest. He never regains consciousness.[10]

August 26　Selling Lemonade While Black, Being a Kid While Black (Newburgh, New York): An anonymous neighbor calls police on six-year-old Elajah Sgorbissa and her friends for operating a lemonade stand. Responding officers purchase lemonade from the stand and praise the children for their entrepreneurial efforts.

September 19　Being a Kid While Black (Orlando, Florida): A six-year-old Black girl is handcuffed, arrested, and transported to a local police station for having a temper tantrum at school.[10]

November 17 Grieving While Black, Lodging While Black (West Memphis, Arkansas): In the late evening, police officers question, pin to the ground, and then handcuff Shawnda Brookshire, thirty-three, for standing in the parking lot of the hotel where she and family members are staying while making funeral arrangements for her recently deceased four-year-old daughter.[3]

2020

January 15 Being a Kid While Black (Silver Spring, Maryland): Police officers detain and handcuff a five-year-old Black boy who has run away from school.[17]

January 24 Banking While Black (Livonia, Michigan): Sauntore Thomas, a forty-four-year-old Air Force veteran, attempts to deposit two checks he has received as part of a racial discrimination settlement at his local TCF Bank branch. Bank employees accuse him of fraud and then call the police.[1]

February 9 Sleeping While Black (Vallejo, California): Police respond to a report that a person appears to be passed out in a vehicle in the Taco Bell drive-through. Within moments of waking up driver Willie McCoy, twenty, is killed in a barrage of gunfire, having been struck by at least twenty-five rounds.[12]

February 23 Jogging While Black (Brunswick, Georgia): While jogging through the Satilla Shores neighborhood in South Georgia,

Ahmaud Arbery, twenty-five, is chased and then killed by three men in a truck who believe him to be a burglar departing the scene of a crime.[2]

March 13 Sleeping While Black (Louisville, Kentucky): In the early morning hours, police officers forcibly enter the home of emergency room technician Breonna Taylor, twenty-six, rousing her and her boyfriend out of their bed and firing thirty-two shots, fatally wounding Taylor as she stands in the entry hall of her apartment.[6]

April 10 Attitude While Black (Miami, Florida): University of Miami physician Armen Henderson, thirty-five, is approached by a police officer and asked for identification as he is loading a van parked in front of his home. Henderson is handcuffed by the officer for giving "an attitude."[10]

May 23 Dancing While Black (Alameda, California): During his morning exercise routine, Mali Watkins, forty-four, is wrestled to the ground, handcuffed, and arrested when police respond to a report that a Black man is dancing outdoors.[12]

August 17 Jogging While Black (Queens, New York): During Tiffany Johnson's midday run, a white woman approaches the thirty-seven-year-old jogger, throws a glass bottle at her, calls her the N-word, and follows her along a portion of her route, yelling racist taunts and epithets.[9]

August 24	Aging While Black (Oklahoma City, Oklahoma): Claiming to have an arrest warrant for her son, police officers enter the home of seventy-four-year-old Ruby Jones, handcuff her, and drag her to a waiting police car, breaking her right arm.[5]
August 27	Jogging While Black (Deltona, Florida): Police officers detain and handcuff US Army veteran and nurse manager Joseph Griffin, twenty-eight, because he fits the description of a man suspected of stealing a leaf blower from a neighborhood home.[5]
September 8	Grieving While Black (Lorain, Ohio): Police officers arrive at a home where over a hundred family members and friends have gathered following the funeral of twenty-three-year-old Charles Pierre-Louis. Officers break up the gathering, which they classify as a riot, and arrest five of the attendees.[1]
October 6	Jogging While Black (Boston, Massachusetts): Bena Apreala, a twenty-nine-year-old real estate agent, is jogging through his neighborhood when he is stopped and questioned by a group of white men claiming to be US Immigration and Customs Enforcement agents.[17]
December 4	Going Home While Black (Columbus, Ohio): A police officer shoots twenty-three-year-old Casey Goodson Jr. in the back, killing him as he enters his home.[2]

2021

January 15 Aging While Black, Driving While Black (Kenosha, Wisconsin): After a low-speed chase, police officers stop seventy-seven-year-old Margaree Burns, a retiree with physical and mental disabilities. Officers tase her, take her down to the ground, and arrest her.[2]

January 16 Shopping While Black (Westlake Village, California): High school student and youth sports coach Malik Aaron, seventeen, is shopping for snacks at Target with two friends when store employees accuse them of loitering, prevent them from exiting, and subject them to questioning by sheriff's deputies.[7]

January 27 Delivery While Black (Tacoma, Washington): In the early morning hours, while driving his regular newspaper delivery route, Sedrick Altheimer, twenty-four, is followed for several blocks by a local sheriff in an unmarked SUV. In a 911 call from his vehicle, the sheriff falsely reports that Altheimer has threatened his life, triggering a countywide response from multiple law enforcement agencies.[2]

March 2 Parenting While Black (Lakeview, Illinois): A school staff member reports JaNay Dodson, forty-one, to the Illinois Department of Children and Family Services for being seven minutes late to pick up her ten-year-old child.[3]

March 5	Banking While Black (Southington, Connecticut): Gwen Samuel, the fifty-five-year-old CEO and founder of the Connecticut Parents Union, enters the Southington branch of TD Bank to withdraw $1,000, but the teller refuses to complete the transaction, citing her discomfort with Samuel's request.[3]
April 3	Aging While Black (Camarillo, California): A seventy-year-old Black man is driving a car with the letters *BLM* prominently displayed when a younger white man pulls up beside him, shouts racial slurs and obscenities, and throws an object at his car.[5]
April 11	Driving While Black (Hennepin County, Minnesota): During an afternoon traffic stop, Daunte Wright, twenty, is shot and killed by a local police officer after being pulled over for driving with expired tags.[10]
May 12	Being a Kid While Black (West Columbia, South Carolina): Police respond to calls that a student is having a tantrum. Officers apprehend and handcuff the student, a nine-year-old Black girl.[8]
June 24	Driving While Black (Wilmington, Delaware): Martiayna Watson, twenty-nine, is pulling out of a service station when four unmarked police cars block her vehicle and several undercover officers surround her with weapons drawn. Officers drag her from her car, handcuff her, and hold a Taser against her neck before realizing she is not the suspect they are seeking.[2]

July 7 Voting While Black (Houston, Texas): Hervis Rogers, sixty-two,
 is arrested for voter fraud after casting ballots in local and
 national elections while on parole and therefore ineligible to
 vote under Texas law. Rogers was convicted of burglary in
 1995 and was released on parole in 2004.[10]

July 21 Flying While Black (Dallas, Texas): After a one-and-a-half-hour
 flight from Denver, twenty-one-year-old Lakeyjanay Bailey and
 her four-year-old sister, who is white, arrive at the Dallas Fort
 Worth International Airport, where they are questioned by
 police officers responding to an emergency call by airline staff
 who suspect the older Bailey of human trafficking.[3]

August 7 Jamming While Black (Memphis, Tennessee): Alvin Motley
 Jr., forty-eight, is killed by a security guard during a dispute
 about the volume of the music he is playing while pumping
 gas at a Kroger Fuel Center.[17]

August 26 Sleeping While Black (Washington, DC): Antwan Gilmore,
 twenty-seven, is killed by police officers responding to
 reports of a driver asleep at a traffic light. Multiple officers
 approach Gilmore's car, and when the car starts forward as he
 awakens, police fire several rounds into the vehicle.[17]

September 13 Singing While Black (Hephzibah, Georgia): Police officers
 handcuff and arrest Christopher Jefferson, twenty-seven, for
 singing and rapping too loudly while walking down the street
 and listening to music on his headphones.[5]

SOURCES

1 ABC News

2 Associated Press

3 *Atlanta Black Star*

4 *Baltimore Sun*

5 CBS News

6 *Chicago Tribune*

7 *Los Angeles Times*

8 NBC News

9 *New York Daily News*

10 *New York Times*

11 *Saint Louis Post-Dispatch*

12 *San Francisco Chronicle*

13 *Syracuse Post Standard*

14 *The Guardian*

15 The Root

16 *USA Today*

17 *Washington Post*

ACKNOWLEDGMENTS

This book began as a series of drawings that I posted on social media during the summer of 2020. Many thanks to Ariel Richardson at Chronicle Books for scrolling through these images and seeing the potential for a book. A heartfelt thank you to Natalie Butterfield, my editor at Chronicle, for her guidance and support in bringing this project to fruition. Thanks as well to her team, for their thoughtfulness, creativity, and expertise.

My sincerest thanks to Alicia Garza for providing the foreword for this project. The artworks in this book were inspired by the millions of people who took to the streets in the summer of 2020 in defense of Black lives. I was deeply moved by the worldwide call for recognition that the condition of being Black is not a crime. I extend additional thanks to Alicia Garza and to her fellow activists Patrice Cullors and Opal Tometti, for turning a simple truth into a global call for justice.

I am deeply thankful to my parents, Kathleen Mance and Alphonzo Mance, Sr., for modeling for me what a lifelong passion for knowledge and truth could look like. Many thanks to my brother, Al Mance, Jr., a long-time defense attorney, for providing insights into the means by which everyday Blackness is criminalized and surveilled. I am forever grateful to my fabulous partner, Cassandra Falby, for her love and encouragement and for the many ways she has supported my art habit, even as it consumes more and more space in our home.

Finally, this book owes a debt of gratitude to Black people everywhere, who meet the skepticism and suspicion of others with steadfast refusals to scale back the scope of our lives, our joys, and our love for ourselves and each other.